Drawing
a Complete Course

Lucy Davidson Rosenfeld

J. WESTON
WALCH
PUBLISHER

PORTLAND, MAINE

1　2　3　4　5　6　7　8　9　10

ISBN 0-8251-1193-5

Copyright © 1987
J. Weston Walch, Publisher
P.O. Box 658 • Portland, Maine 04104-0658
Printed in the United States of America

Contents

Introduction

A word to students: This is a drawing course designed specifically for high-school students. It is a "hands-on" course in how to draw and how to appreciate drawings. Its main purpose is to open up the world of drawing to those of you who long ago decided you couldn't draw, and to you who already love it. Drawing is fun, no matter how good or skillful you are, and it *can* be taught. The exercises in this book are designed to teach basic concepts: space, composition, media, and design. They will lead you step by step into clear sight and expression. You will have the chance to try everything from landscape perspective to political art, from still life to seascapes, from abstractions to outdoor sketching.

There are over 110 master drawings included. They are not here to be copied, but to show you some of the many ways different artists have drawn the same subjects, and to make you aware of the world of art. There are projects and discussion questions for classes to do together, but mainly this is a book for each of you to enjoy. Art is an individual activity and no two drawings should look just alike. Use your imagination and express your own personality as you follow the course.

A word about the illustrations: the diagrams are there to guide you, not to imitate. If your picture comes out looking entirely different from the diagram and yet you have carefully followed instructions, all the better! Study the master drawings at the end of each chapter carefully. These artists probably saw much the same world around them but chose to draw what they saw in different styles and with different aims. You don't have to like them all equally, but you should try to understand the artists' aims.

You should experiment with media as much as possible. You will probably find certain media more fun, or easier to use, but try them all! Keep in mind that the master drawings include the largest possible variety of media, from pen and ink to pastel, from lithograph or prints to charcoal. (While some prints are technically not considered drawings, they are nevertheless done with line. Since this is a book about line, they are included too.) Have fun!

A word to teachers: This course should be treated as a series of experiments by your students. Some of them may find it difficult to work with a particular medium because it is too delicate, and others may be frightened of bold expression. Encourage them to try all of the media, but if they are unable to master a particular exercise, allow them to change after several tries. Frustration at this early stage of learning can defeat the purpose of the course. (Larger paper often helps in such cases.) It is essential that you

encourage enthusiasm and free expression and good discussion of the drawings that end each chapter. The object is not only to develop "artists" but also to make an appreciative and knowledgeable art audience. We hope the arrangement of these chapters, the variety of exercises and approaches, and the inspiration of the brilliant master drawings will bring your students a whole new world of enjoyment.

Chapter I

Bold and Fine, Wet and Dry: Trying Out Drawing Media

MEDIA

Media means the materials you use for making your picture. You can use many different kinds of media, from different kinds of paper to different pens, pencils, or chalks. Before you begin learning *how* to draw, you should try the different media.

In this chapter you'll try the six most common media: the pencil, pen with ink, charcoal, chalk, magic marker, and brush with ink. Each has strong points and weaknesses. Some media are better for precise, clear drawing; some for hazy, delicate drawings; and some media is best for bold designs. The type of paper can also vary, ranging from soft newsprint to heavy or tinted paper.

Begin by trying the following exercises. You'll learn how each medium is used. And you'll have a chance to experiment and find which media you like best. Don't worry: you won't have to draw anything difficult. You will make some pictures that are just designs. Other pictures may have a subject like a city scene, sailboats, or trees. These subjects will be easy to recognize with just a few shapes and lines. Sailboats, for example, can be recognizable with just a few triangles. (Later you might want to draw a more detailed sailboat.)

1. Pencil

Most quick sketching is done with a pencil. You know how to use a pencil for writing, but drawing with one is a little different. Loosen your grip on the pencil; you can't hold it as tightly for drawing as you do for writing. Your arm should be able to swing freely in front of you as you draw. Give yourself space so that you can slide your pencil-holding hand across the paper without hitting anyone. Hold the pencil so you can pull it towards you or away from you without running into something. Don't press heavily.

1

Avoid small cramped motions, such as those you might make when doing a math problem!

What you will need for Exercises 1-5: A #2 pencil with a medium-sharp point. Plain white paper, at least 8″ x 11″ (not newsprint).

EXERCISE 1 Straight Lines with a Pencil

There is no subject or theme, only lines. Draw a 1″ margin around your paper. This makes a frame for your work. Hold your pencil loosely and draw about six vertical lines *from top to bottom.* Your lines can be straight or slightly curved. See how much finger control you need to adjust the line. Don't press heavily. Now draw a more scribbly line, moving back and forth over the line. These lines will be less sharp and clear, but they will be thicker and heavier. These are two kinds of pencil lines.

EXERCISE 2 Curving Lines with a Pencil

There is no subject or theme, only curving lines, in this exercise. Draw a 1″ margin around your paper. Place your pencil point at the margin wherever you prefer. Make a continuous curving line that covers most of your paper within the margin. Make a second curving line, this time using the side of your pencil point. This line will be hazy. Always draw the pencil toward your body. Let your arm move freely!

EXERCISE 3 Free Circles with a Pencil

Now try a full page of circles, using your arm fully. Pretend the pencil is attached to your hand. Think of it as an extension of your hand and arm. Don't pick up the pencil as you complete each circle, but work in one continuous line. Use as much of the page as you can for one large set of circles. You should feel as if you were stirring a large pot.

EXERCISE 4 Arcs and Angles with Pencil

You want to be able to use your arm and hand freely. But you also want to have some control over where your pencil is going. For the next exercise, draw a 1″ margin. Now put seven or eight dots randomly along the margin. Connect the dots with a simple motion, using either straight or curved lines. Do not press hard. Try to make the lines in one gesture each, without erasing.

Practice holding the pencil at different angles. Let your arm guide your hand, as if you were pulling a string. Some of these drawing motions will be toward your body, others away from you in a kind of backhand movement, as if you were throwing a frisbee. Hold the pencil loosely.

EXERCISE 5 Continuous Line

Finally, try all of the kinds of pencil lines you can. Make a 1″ margin. Don't take your pencil off the paper and use the entire surface, except the margin. Make a long line, including all of the kinds we have tried: include straight, curving, scribbly, side-of-the-point, and sharp, clear lines in your continuous line. Try several of these drawings.

2. *Pen and Ink*

The pen can do most of the things a pencil can, except be used on its side to make the kind of hazy line you have tried with the pencil. And it can't be erased! But it is much better than a pencil for making a sharp dramatic black line. It is also good for contrast; you can get *both* heavy *and* light lines that are very clear and strong. Artists who want a lot of small ornamentation and detail like it because of the clean line. But since you can't erase it, it is better for more finished or complete work. (You have to be careful not to smudge pen lines with the side of your hand as you draw. In the following exercises remember to lift your hand off the paper where you have just made pen lines.)

What you will need for Ex. 6-8: There are several kinds of pens. Artists most often use a straight pen with exchangeable points and black drawing ink, but you do not need that to start with. These exercises can be

done with black ink roller-point pen, or a thin-point, felt-tipped pen. (Ball-point pens are not good for drawing. They leave blotches and do not work well when you hold them at an angle.) If you use a roller pen you won't need ink. If you use a straight pen, use black India ink. You will need several sheets of strong white paper (not newsprint).

EXERCISE 6 Pen and Ink Techniques

Use the same techniques you tried with the pencil. See what the pen can do with straight, curved, and repeated lines. Move it freely over the paper. Try curlicues, loops, and swirls. Sometimes draw the pen toward you, and sometimes away. If you are using a pen with bottled ink, see how much ink you need and what kind of pen points work best for you.

You will notice that the pen easily catches the movement of your arm. In some ways it seems easier than the pencil. The lines you are making are probably sharper and more dramatic than pencil lines. Try lighter and heavier lines, and light, delicate repeated strokes. To make very light lines, keep the side of your hand on the paper as you draw. (But don't smudge your work.)

EXERCISE 7 Pen and Ink: Imaginary Garden

Pen and ink are the best media for detail. You can make small circles, dots, shapes, delicate lines, and lots of interesting patterns. No matter how small, these designs can always be clear in pen and ink. Try combining a variety of small details or ornaments in a picture of a garden. Begin with a 1″ margin. Combine small details with a few heavier lines. Make some of your designs look like flowers or leaves, and some of the heavier lines look like stems or tree trunks.

Use all of the area within your margin. In other words, don't make your garden only at the bottom of the picture with a lot of empty space above it! If you have trouble getting started on this drawing, you can see one example of the imaginary garden exercise on the next page. Obviously, this is not the only way to make this picture. Use your imagination! And use your pen and ink technique to experiment.

EXERCISE 8 Pen and Ink on a Wet Surface

Using ink on a wet surface is fun, because you leave some of your picture to chance as you let the ink "run" a little bit. First tape your paper to the table or drawing board to keep it from wrinkling when wet. Make your 1″ margin *with a pencil.* Now wet the paper with a sponge or a wet paper towel. It should be moist, but not so wet that you have puddles on it. Use strong paper that won't disintegrate when wet.

For this exercise you need a straight pen with a bottle of ink. (The wet surface will keep a roller pen from working.) Experiment with a few lines on the wet surface. See how much ink you need so that your picture won't be entirely made up of ink blots. On the other hand, a slightly "runny" line can be interesting and decorative. Drips and drops of ink on a wet surface can create unusual effects and pictures of chance. (Although you may not consider these "chance" drawings "art" in the traditional way, this technique is very common in the 20th century.)

After you have experimented a bit with wet-surface drawing try the following exercise: Make three large shapes on the top half of your picture. Allow the ink to run slightly. Now add some lines in the bottom half of the picture. Your drawing can suggest trees, balloons, flowers, or clouds and rain. Our drawing of balloons is just one way this exercise could look.

Ex. 7: Imaginary garden

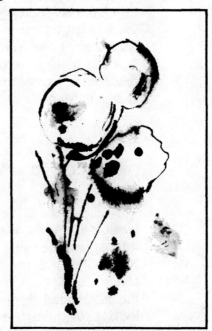

Ex. 8: Pen and ink on a wet surface

6

3. Charcoal

Charcoal is a favorite medium of many artists because it can be used for such a variety of purposes. It is good both for finished drawings and for preliminary drawings for future paintings. It has a bold but soft quality, and can be very easily erased. It can even be smudged out with your fingers. Unlike pen and ink, a charcoal line can be changed again and again, and for this reason most teachers prefer it. If you use the end of a stick of charcoal you can make a strong bright line. If you hold it on its side you can use it for easy shading. Hold it as you would your drawing pencil, loosely, or for flat shading, on its side. Don't let your hand smudge where you have drawn.

What you will need for Ex. 9-11: You should have several short pieces of black Vine charcoal (heavy, #24) which can be broken off from a full stick. Each piece should be about 3" long. You should also have a charcoal rubber eraser, which is especially soft. You should have newsprint paper.

EXERCISE 9 Winter Trees in Charcoal

Charcoal breaks off easily. Don't press too hard. Hold it loosely, not as if you were about to write with it. Pull the charcoal toward yourself, with the back of your hand against the paper. But don't *drag* your hand along the paper because you'll smudge your lines. Draw five or six strong *downward* lines, making tree trunks. They can bend slightly. Using a lighter touch, make some more delicate lines that look like branches or tops of trees. Experiment with the kinds of lines charcoal can make.

EXERCISE 10 Pine Tree with the Side of the Charcoal

Using the side of the charcoal can give you shaded areas. Begin with a 1" margin. Fill in your entire picture area with a gray tone made by using the flat side of your charcoal. Now, still holding the charcoal on its side, make a series of arcs sweeping from left to right. Make these areas darker than the background. If you add a line or two you will have a hazy-looking pine tree. (See example.) (Notice how charcoal can suggest shapes and themes without precise drawing. On the other hand, it is not good for clear details or delicate lines.)

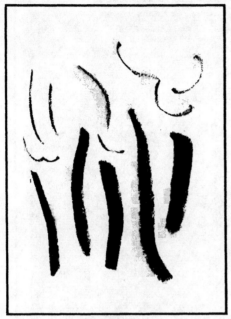
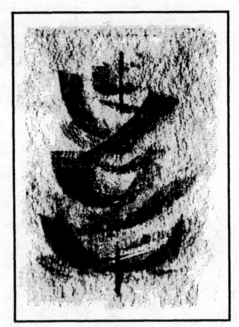

Ex. 9: Winter trees Ex. 10: Pine tree

EXERCISE 11 Underwater: Charcoal and Eraser

Charcoal is one medium that can be easily and cleanly erased. The erasures can actually be part of your picture. For your underwater exercise picture, make a 1″ margin and then use the side of your charcoal to black in the entire area. This time make the area very black. When you have it all black, take your eraser and clean off thoroughly three or four smallish shapes—not just dots, but real areas. Make these areas in simple fish shapes. Work over them until they are clean and white.

Now make some lines in your picture. Spread out the white areas and lines so that your eye keeps moving around the picture. Don't make each shape match another just opposite (*symmetry*). Now add some darker black shapes with your charcoal, where you think they will look right. They can be in the shape of fish or plants, or just shapes.

This exercise should show you two things: how to use charcoal and eraser, and how to place lights and darks so that you get an interesting design. You can try this technique again, using different themes.

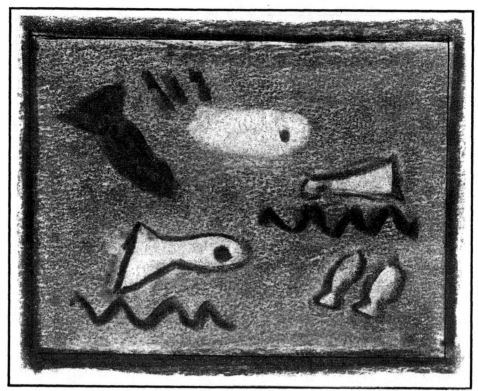

Ex. 11: Underwater—charcoal and eraser

4. Pastels or Chalk

Pastels or chalk are a lot like charcoal. They smudge easily, they have a fuzzy, delicate quality, and they can be used either on end or on their side to cover large, hazy areas. Though they have been a favorite medium of artists for a long time, they take a lot of practice to handle well. They are the only drawing media we will use in color.

What you will need for Ex. 12 and 13: You should have one chalk of any color, a soft pastel. (This word doesn't mean that it should be a light pink or blue "pastel" color, but a soft kind of chalk.) Blackboard chalk is not good because it is too hard. You can use newsprint, or you can substitute soft white chalk on black or dark-toned paper.

EXERCISE 12 Sailboats in Chalk

As you did with charcoal exercises, make a 1″ margin and then cover your entire page with the side of your chalk, making a hazy tone over all of it. Still using the side of the chalk, make three or four large darker triangles. Balance them well, avoiding symmetry. Don't put them in a row. Tip each triangle slightly. These will be the sails of your boats. Using the point of your chalk, make a few lines under each sail; these will be the boats. These are the two basic ways chalks can be used: in large hazy areas, or with the end, for a soft line.

EXERCISE 13 Vase of Flowers in Chalk

Make a rough 1″ margin with your chalk. (Choose a different color from the one you chose for the last exercise.) Using the side of the chalk, make eight or nine smudgy spots on the top half of your paper. Draw a vase or pot or simple container below the spots. Add lines to suggest stems and leaves. Use the side of your chalk to fill in any areas you wish. Trade colors and add some new tones. Try combining colors.

Your work in chalks will look more like painting than simple drawing. You can use various colors on top of one another for mixed tones, and you can fill in the background if you want to.

* NOTE: All chalk or charcoal drawings should be sprayed with *fixative* if you want to keep them without smudging.

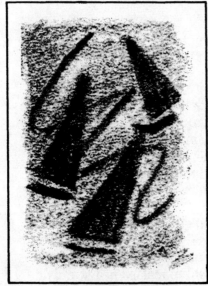

Ex. 12: Sailboats in chalk

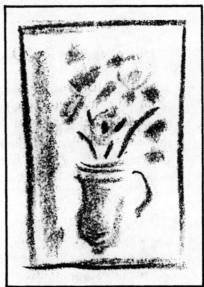

Ex. 13: Vase of flowers in chalk

5. Black Marker

Markers are a fairly recent invention. They are better for making signs and posters than for artwork. However, the strong, clear quality of marker line does have some advantages.

What you will need for Ex. 14 and 15: You should have one black marker with a thick end (not pointed like a pencil) and white paper that is not newsprint.

EXERCISE 14 City in Black Marker

City scenes are mostly made of rectangular or box shapes. Markers work best when you use them to make straight lines. As you do this drawing, experiment with your marker, using it on its flat edge and on its angled edge. Begin by making a margin 1″ from the edges of your paper. Now draw some big or small rectangles which may overlap. Some can be blacked in. Others can just be outlines. The larger rectangles can look like city buildings. You can add windows, streets, or simple trees.

You will find the marker is good for strong, dramatic accents and bold lines. It is harder to use for making delicate designs or smaller shapes. It can't make hazy or shady areas like chalk or charcoal can. Your city scene should use the whole paper, not just the bottom half, and it should be strong and dramatic with the heavy marker lines.

EXERCISE 15 Outer Space in Black Marker

This exercise is the opposite, in a way, of the last one. In your city scene you made black lines and shapes on a white background. Now you will make an almost entirely black picture with white accents. Begin by making your 1″ margin with your marker. Now make some (six or eight) odd shapes all over the picture. Fill in all around the shapes, leaving them white.

Your picture should be completely black with contrasting white shapes that could look like flying objects, stars, or whatever other shapes you think you might find in outer space. The marker is a good choice if you want to make a heavy and dramatic picture with lots of contrast but not much detail.

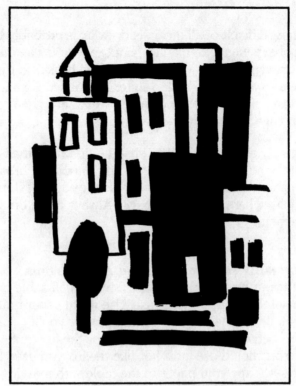

Ex. 14: City in black marker

Ex. 15: Outer space in black marker

6. Brush and Ink

The most difficult of all media in drawing is probably brush and ink. It takes a lot of experience to manage, but the results can often be beautiful. Oriental drawing is done with a very pointed brush, so that every line is almost as clear as a pen line. Wider, softer brushes make a fuzzier line. When you use a pointed brush you should wet it, and then roll the wet tip between your fingers until it makes a point. Dip it in ink, but don't drown it.

Hold it gently and draw lightly, using the tip rather than mashing it down against the paper. When you use a soft unpointed brush, hold it at an angle to the paper and draw it gently across the surface. Don't mash it down to the joint where the bristles begin. Always clean brushes carefully after you use them.

What you will need for Ex. 16 and 17: two brushes that you can exchange with your neighbor. One should be a small sable brush (#5), and the other a pointed Chinese-style brush. Use white paper that is heavier than newsprint. If you use rougher textured paper you'll get a more interesting drawing, because the rough paper keeps the ink from sinking in immediately. You should use India ink, like the ink you used in your pen and ink exercises. Tape your paper to the table with masking tape to keep it from wrinkling.

EXERCISE 16 Designs with Brush and Ink

Make a 1″ margin with a pencil. This picture will have no theme; it will just be a collection of patterns. Divide your paper into roughly six horizontal sections. Fill each section with a different pattern or design. At the top, try a heavy, side-of-the-brush design. Next try more delicate lines or shapes. Below that try another brush and ink pattern. Continue with lines of heaviness, or of delicate pattern. At least one strip should be heavy and bold.

You should soon discover what you can and can't do with a brush, and how much ink it takes to make clean strokes. Remember that the angle of your brush matters. The most delicate work is done with the brush almost straight up and down. The largest areas of black are done with the brush almost flat to the paper so that you use the full side of the bristles.

Ex. 16: Designs with brush and ink

EXERCISE 17: Chinese Brush Drawing of a Stem with Flowers or Leaves

Chinese and Japanese drawings made with a pointed brush and black ink are some of the most beautiful drawings. (You'll see some examples in this book.) Though it takes a lot of practice to do well, you can experiment with the technique.

Make a 1″ margin in pencil. Take a pointed brush and dip it lightly into the ink. Make a curving stem from top to bottom of your paper. Your brush should be almost as sharp as a pen point. (If it loses its point, roll it on a piece of scrap paper.) Add some leaf or flower shapes to your stem. You can be quite detailed with this sharp brush. Make a few accents, or dark spots, but don't rub the brush back and forth.

14

Ex. 17: Chinese brush drawing

With these exercises you've tried the most common drawing media. And you should be able to recognize the different media when you look at other people's works. You probably have one or two favorites that you found most fun to use. (NOTE: There are other drawing media too, of course, including crayons, scratchboard, and the many kinds of print-making media. Etchings, lithographs, seriographs, etc. all use lines, too. You'll see some examples of these processes throughout this book, and if you have the opportunity, try them too!)

The rest of this course will show you HOW to draw, using these media and some of the ideas from the exercises. In the following pages you can see how great artists used different media, and occasionally combined them (*mixed media*). Look carefully at the techniques and styles.

Master Drawings

Pencil Drawings

1. *Jockey on a Galloping Horse* by Edgar Degas
2. *Man Playing a Drum* by Georges Seurat

Pen and Ink

3. *Fortified Harbor with Shipping* by Vittore Carpaccio
4. *Locomotive* (pen and ink and brush and ink) by Reginald Marsh
5. *San Remy Under a Starry Sky* by Vincent van Gogh
6. *Drawing* by André Masson

Brush and Ink

7. *A Disciple of Buddha* by Chin Nung
8. *Two Horses* by Nicolas Poussin

Pastel and Charcoal

9. *Head of a Girl* by Jean-Baptiste Greuze
10. *Drawing of a Dancer* by Edgar Degas

Mixed Media

11. *The Year 1939* (ink and ink blots) by Max Ernst
12. *Landscape with Hermits* (pen and brown ink, gray wash, and white on blue-gray paper) by Polidoro da Caravaggio
13. *Horse and Cavaliers* (scratched on black-painted board) by Marino Marini

1. *Jockey on a Galloping Horse,* Edgar Degas

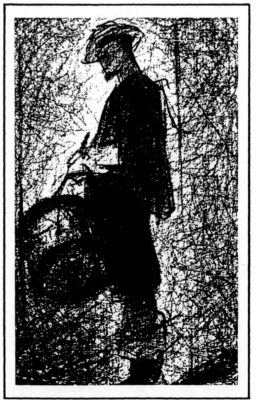

2. *Man Playing a Drum,* Georges Seurat

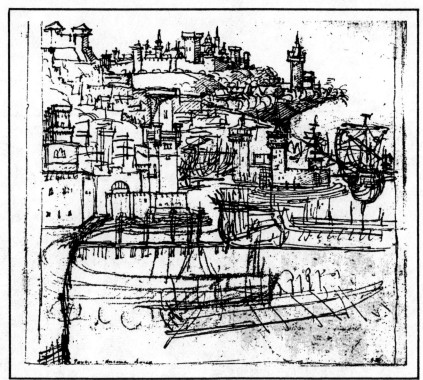

3. *Fortified Harbor with Shipping,* Vittore Carpaccio

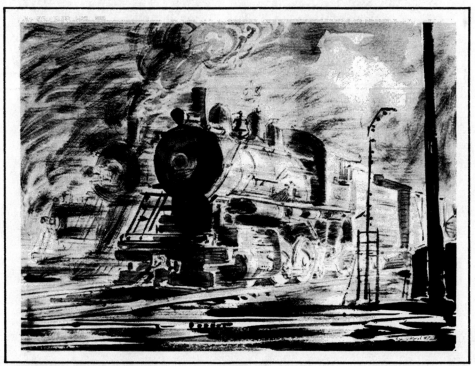

4. *Locomotive,* Reginald Marsh

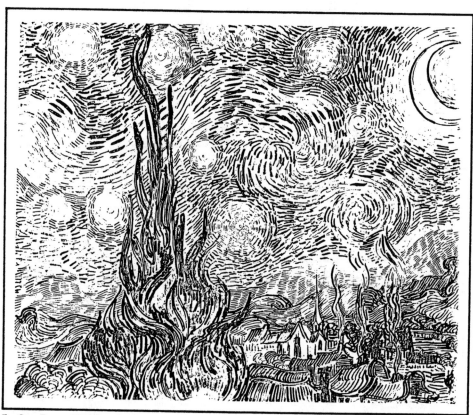

5. *San Remy Under a Starry Sky,* Vincent van Gogh

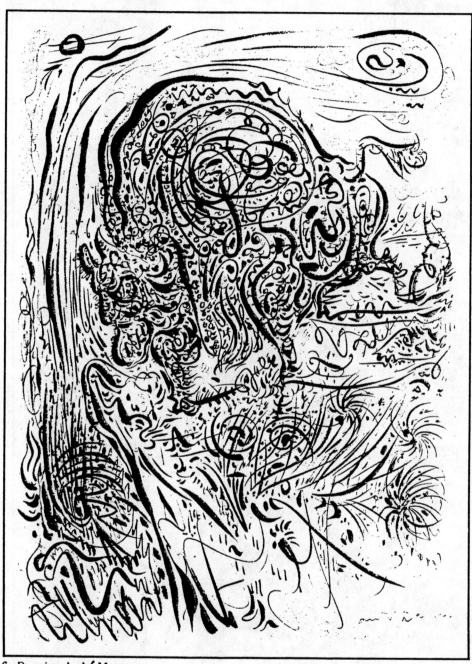

6. *Drawing*, André Masson

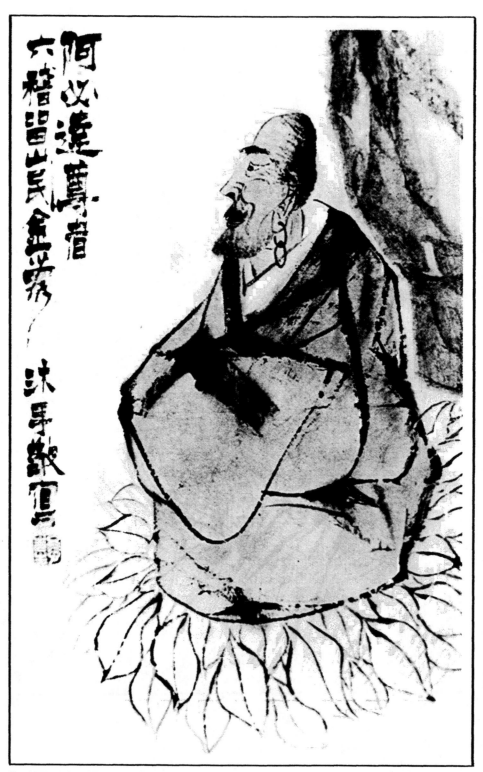

7. *A Disciple of Buddha,* Chin Nung

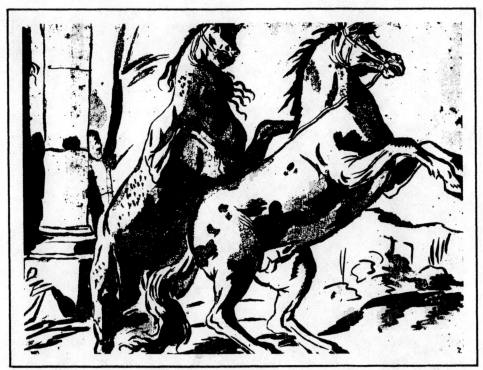

8. *Two Horses*, Nicolas Poussin

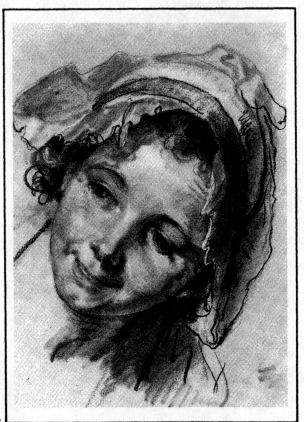

9. *Head of a Girl*, Jean-Baptiste Greuze

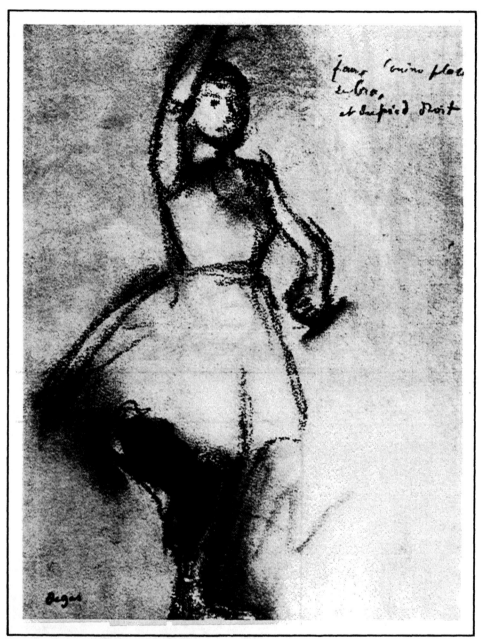

10. *Drawing of a Dancer*, Edgar Degas

11. *The Year 1939,* Max Ernst

12. *Landscape with Hermits,* Polidoro da Caravaggio

13. *Horse and Cavaliers,* Marino Marini

Chapter II

From Boxes to Houses: Learning How to See

Now that you have tried the different drawing media, you can start to learn *how to draw*. Drawing begins with learning *how to see* the way an artist sees. That means that you have to look at an object and see its simplest forms. You eliminate the details so that you can find the basic structure as you look. The details can come later. To simplify like this, you have to see the object in relation to the space around it. Remember, everything occupies a certain space; you do, small objects do, a house does, too. Seeing the area *around* an object helps you to judge the proportions and size of the object.

The first thing for you to try to draw is based on the simplest shape: the box or cube. Most architecture is built in geometric shapes: the squares, rectangles, circles, triangles. When you learn to see something as complicated as a house or apartment building as a series of basic geometric shapes, you will be on your way to learning to draw it. The basic form of most buildings is a three-dimensional rectangle. That means that it has width, length, and depth.

In the apartment building the basic shape is a vertical rectangle or box. Sometimes towers or balconies or other details are added, but the *basic shape* is what you are after. In the suburban house, the form is basically a horizontal cube. In many houses you can spot several horizontal rectangles, and sometimes vertical ones. Churches are usually a combination of box shapes, with a triangle or cone-shaped steeple. To draw any of these buildings, you should first know how to make a three-dimensional cube. (If you've taken geometry already, you will know how to do this.)

EXERCISE 1 Cubes

What you will need: charcoal, a charcoal eraser, a newsprint pad, and a deep cardboard box, like a shoe box. (These supplies are all you will need for the following six exercises.) Any arrangement using boxes should be a little below your eye level, so you can see the tops of the boxes.

25

Place the closed box in front of you. Turn it slightly away so that you can see more than the front side. Study the box before you begin to draw. Notice that all the lines are straight lines—either vertical, horizontal, or angled. Where each line meets another is an angle. Notice how the angles match at opposite points, making certain lines parallel.

Begin with drawing your box several times from different directions. Include the line of the table, where the box sits. Make your drawings large and clear. Now take the lid off the box and draw it again, adding the "inside" lines too. Keep in mind that buildings, whether apartment houses in a city or houses in the country, have three different dimensions: height, width, and depth. Your box drawing must have those three dimensions, too.

EXERCISE 2 Your Own House

Now that you have learned to draw a cube, try to remember what your own house looks like. Place your shoe box on its side or end, depending on whether you live in a tall house or a horizontal house. Make a light outline of the box. Now add the important features of your house. The *roof:* is it in the shape of a triangle? The *windows:* how many more rectangles? Additional parts such as attached garage, porch, etc. should be added next.

Make this a simple drawing without details. You can erase the box shape if you want to, after you have used it as a guide to getting the basic form right. (See Diagrams a and b.) Make sure that your angled lines are carefully drawn and are parallel when necessary. (Should you use a ruler? If you can't draw a pretty straight line, you can use a ruler, but not in future exercises.)

EXERCISE 3 Box with Perspective

Perspective is the science of drawing (or painting) so that three-dimensional objects are accurately proportioned and represented in space. *Linear perspective* is a way of showing the depth of an object. It uses lines that meet in the background of the picture to show the proper proportions of the object. (Perspective is a complex subject that you can do some serious work on—a good independent project. Here we will try only one perspective exercise—drawing houses.)

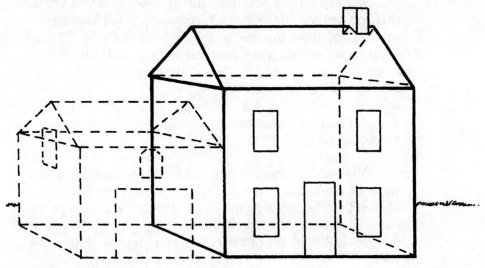

Ex. 2a: Your own house

Ex. 2b: Your own house

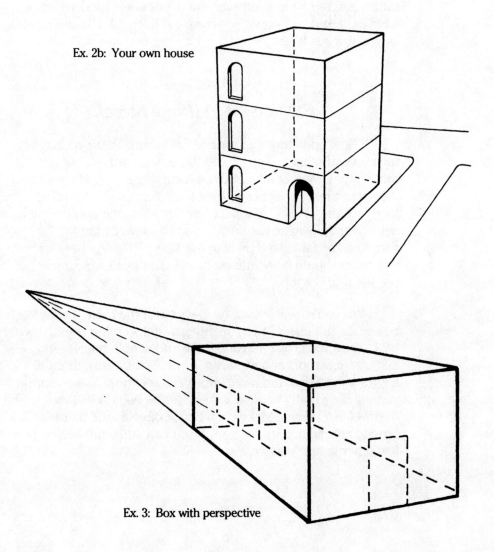

Ex. 3: Box with perspective

Begin by turning your box slightly away from you again, so that you can see one side of it receding, or going back into space. Look at the top and bottom lines of that side. You can see they are angled. If you continue the top and bottom lines of the side back beyond the box, they will eventually meet or intersect in the distance. (See diagram.) This is an example of linear perspective and it is useful to you in drawing any object that you want to place correctly in size and relation to the space around it.

Practice drawing your box several times, continuing those angled lines until they meet. Notice what happens to the other lines of the box; those on the top of the box also change. If you put a window into the side of the box you draw, make sure that the lines of the window follow the correct angles of the outer lines.

Perspective such as this was discovered in the Renaissance, and has been used ever since. But some modern artists have preferred less scientific ways of showing depth and space, as you will see later.

EXERCISE 4 Village Street

Now bring together four or five boxes. Share your setup with several other people. Place the boxes on the table as though they were buildings along a curving street. Make sure they aren't in a perfect row. Turn them each slightly so that they face the "street" a little differently from one another. (If it helps you to imagine the street, place a long scarf in a "C" shape on the table to represent the street.) Remember that this setup should be a little bit below your eye level so you can see the roofs or tops.

Now you're ready to draw. Begin with the road. It should be simple and clear—two roughly parallel, curving lines. Now try to draw the boxes, making them into simple houses and adding a few roofs and windows, if you like. Be sure that the angles and lines of the basic cubes are accurate. Make your vertical lines really vertical; otherwise the houses will look as if they're falling down. Make each house have a little bit of ground around it. (See diagram.) You can add a hill behind or a few other lines if you want to.

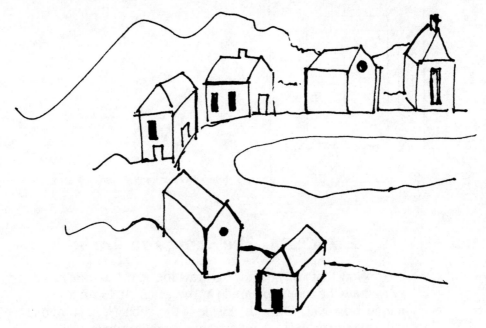

Ex. 4: Village street

EXERCISE 5 Interior of a Room

The inside of a room is also constructed like a box. Turn just one box to face you, open, so that you can see the empty space inside. This time, practice drawing the inside of the cube. Make your drawing almost as large as your paper. Now place smaller squares or rectangular-shaped windows on the back wall and one side wall. Be careful to match the lines of the windows to the lines of the floor and walls. They must be parallel!

Now place two circles in the room. One should be smaller, because it will be farther away, towards the back of the room. But make it sit firmly on the floor area. The other should be larger and nearer the front of the room. (See diagram.) Now you should have an idea of the space inside of a room: the most distant area is the window in the back wall, the middle distance is where the smaller ball is, and the closest space is where the largest ball sits.

Experiment with this exercise by using simple furniture instead of circles, but be sure to make the most distant object smaller than the nearer one.

30

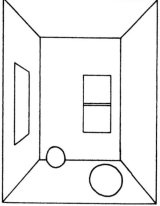

Ex. 5: Interior of a room

EXERCISE 6 *The Room You Are In*

Now that you see how to draw the structure of a room, try to draw the room you are in at this moment. Make a 1″ margin. Now you'll draw the inside of the cube. (You shouldn't add any unusual nooks and crannies; simplify what you can see from your position in the room.) Begin by finding the floor line, which you should place about halfway up on your paper. Next draw the vertical lines at the room's corners. Now add the wall lines and ceiling lines to complete the cube shape. Next add the windows, if any, making sure that the lines are parallel to your basic room lines.

Now place one or two pieces of furniture in the room: make a table or desk or chair or other simple object. (See diagram.) Think of the furniture as box-shaped with the legs of tables or chairs like the sides of the cube. You can now add as many details as you like. Make sure that any additional things you put into the room occupy a definite space: distant, middle, or foreground. The things closest to you will be the largest.

EXERCISE 7 Varying the Media: Houses in Heavy Line

What you will need: heavy black marker, white paper (not newsprint).

Now back to media. Any of these exercises can be done with different media, but the preliminary drawings are best in pencil or charcoal so you can erase easily. Now you should experiment a little with heavy and light line. For the heavy line, use a black marker or charcoal. Go back to Exercise 4 in which you drew a village street. You can make a new drawing or work on top of your original drawing.

With the heavy line you should accent a variety of angles or roof tops or sides of houses to make an interesting pattern. Make some of the areas around the houses black as if they cast shadows. Experiment with large and small black accents until you have designed a strongly accented picture.

EXERCISE 8 Houses in Light Detailed Line

What you will need: pen and ink and white paper (not newsprint).

Go back to pen and ink. Return to Exercise 2, in which you drew your own house or building. This time add details with delicate pen line: include style of windows, flowers, awnings, brickwork, trellis, shutters, etc. Add some surroundings such as trees or other buildings. Emphasize the interesting lines that might contrast with the straight structural lines. For example, the curving lines of climbing vines, drapes in the windows, and wires from telephone poles can be good additions to your drawing.

This should be a light and delicate picture with no dramatic black areas, though you can vary your line from darker to lighter. If you like, you can also add imaginary details.

OPTIONAL

Return to any of the above exercises and try different media and different types of line.

FOR DISCUSSION

The drawing of houses and buildings has always been one of the most common subjects for artists. Following are some examples by well-known artists. See if you can identify the media used, as well as the objectives of the artist. Was the artist interested in detail? In perspective? In recording a complete scene? Or did he or she just use the house theme as a basis for a design of darks and lights or geometric patterns? Look carefully at each picture and see if you can answer the questions.

Master Drawings

14. Nineteenth-century American view of *New Bedford, Mass.*

 What are two reasons that the houses in this picture seem so solid and realistic? What does the shading accomplish?

15. *A Corner of a Courtyard* by François Boucher

 How many rectangles is this picture made up of? Where do you see the use of cube shapes and lines?

16. *Houses near San Marta* by Canaletto

 How does the artist make you know that the houses on the right are closer than those on the left? Compare it with the view of New Bedford (#14). Which is more decorative? Why? Which houses seem more solid? Why?

17. *Village Street* by Morris Davidson

 Which are the strongest lines? How do they help provide unity and interest?

18. *Houses* by Pablo Picasso

 What do you think was this artist's objective? What geometric forms did he think houses were made up of? Without the title would you know what this is a picture of?

19. *Needlework by the Hearth* by William Buytewech

What basic lines can you find that give you some of the dimensions of this room? How many rectangles can you find in addition to all the detail? If you were to remove all of the detail what would be the basic structure of this room?

20. *Interior with Stove* by Charles Sheeler

What are some reasons that this interior looks so much more modern than the last picture? How has the artist used light and dark areas? Which basic lines tell you the structure of the room?

21. *Chinese Farmhouse Among the Trees* by K. Hokusai

How has this artist simplified the scene? Did he use the same kind of simplification as the artists of #18 or #20? How did he use media and pattern to make it interesting?

22. *Schwabing, a Section of Munich* by Paul Klee

How do you know that this is a scene of buildings? Which lines are essential to show that? What has the artist chosen to leave out?

GENERAL QUESTION

Without looking at the dates of the artists in the back of this book, guess which pictures in this chapter are the most contemporary. Explain why you think so.

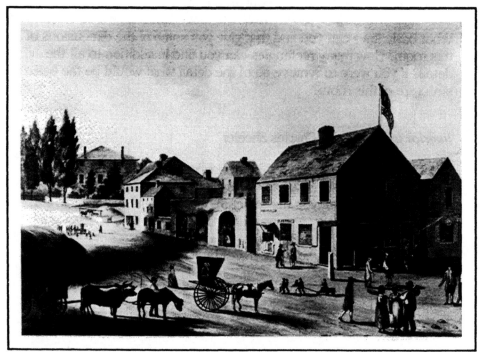

14. *New Bedford, Mass.,* American, 19th century

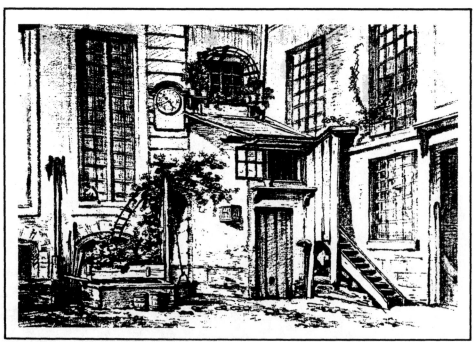

15. *A Corner of a Courtyard,* François Boucher

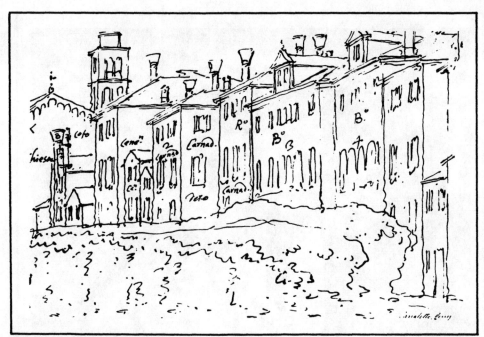

16. *Houses near San Marta,* Canaletto

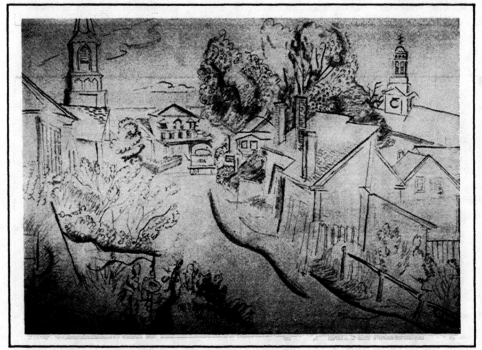

17. *Village Street,* Morris Davidson

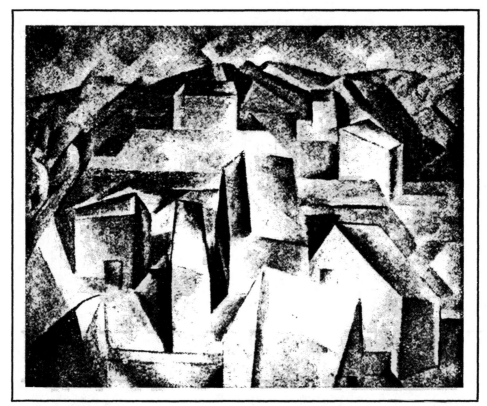

18. *Houses,* Pablo Picasso

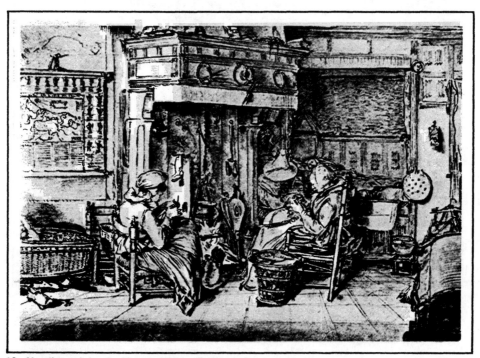

19. *Needlework by the Hearth,* Willem Buytewech

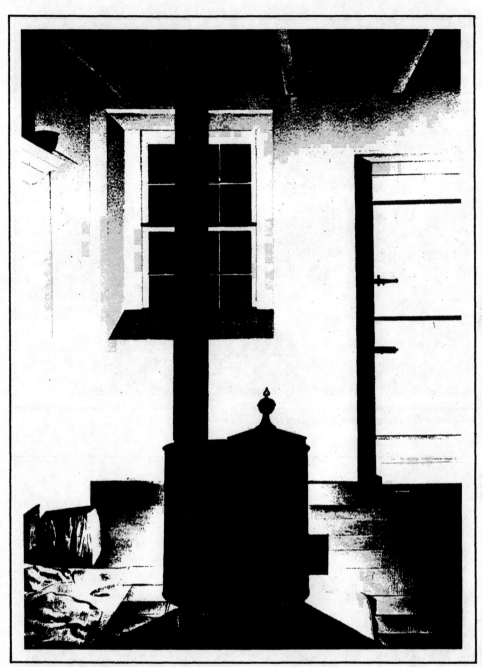

20. *Interior with Stove,* Charles Sheeler

38

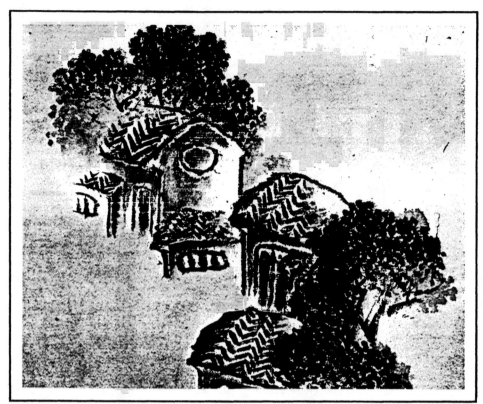

21. *Chinese Farmhouse Among the Trees*, K. Hokusai

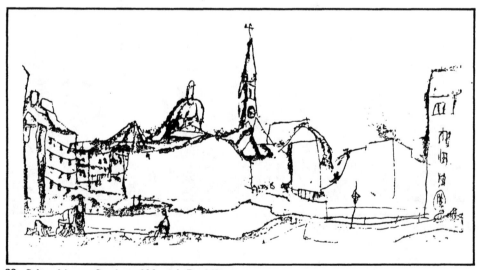

22. *Schwabing, a Section of Munich*, Paul Klee

Chapter III

Over the Mountains and Through the Trees: Drawing Landscape

Landscape drawing is the drawing of any scene you might find outdoors. It can be a village in the mountains, a forest of pine trees, or a factory on a city street. The beauties of nature—flowering trees, and blue mountains with rippling lakes—are the most familiar and enjoyable themes to draw. But even scenes of less natural beauty can make interesting and unusual pictures. Usually landscape drawing is done outdoors so that you can catch changes of light and shadow and accurately see sizes and shapes and distances. As you become better at drawing what you see, you'll want to draw the same scene at different times of day or seasons. But you can begin to learn how to draw landscape right in your room. You should try to make at least one sketching trip outdoors, too.

All landscape drawing must have some feeling of distance or space. By drawing cubes you've seen that perspective allows you to show distance by sending lines toward a distant point. In landscape too, the same system can be used. Though the use of perspective is the most common system, there are other ways to show distance and depth.

The most important thing in beginning a landscape drawing is to find a way to divide your drawing so that there are near, middle, and distant areas. To do this, you have to *see* the same thing in the scene you're going to draw. For instance, if you choose to draw a tree in a field (from nature, a photo, or your imagination) the tree *must be set in space so that it occupies a particular spot*. It might be in the closest part, the middle part, or the most distant. Once you've decided that, you design your landscape just as a photographer would with a camera, as though there were an automatic frame around the amount you can fit in.

Next you have to decide whether the tree will be in the center of the space, to one side, or perhaps only partly visible. Remember, you have to simplify what you see; you can't draw every leaf on every tree, so look for the basic structure. Notice what is around the tree. Is there a hill? Where is it in relation to the tree? Is there another tree nearby? Is it farther or nearer to you? Decide how many important objects will go into your drawing and

which parts of the picture they will go in. Remember, you can always add details later, but at the beginning you should simply identify the major areas of your picture and the basic shapes you want to include. In this way you will get a full picture, not just a portrait of a tree.

Keep in mind as you draw that you have a choice of many different kinds of line. Landscape line can be made up of lots of short, quick lines, or one long, curving, continuous line. You can use heavy, strong lines for accents, or delicate, ornamental lines for detail. The kind of line you use can add rhythm or direction as well as details. Some of the exercises that follow will show you how to represent distance in your picture, how to design the space, and how to use a variety of lines and media.

EXERCISE 1 Tree-lined Road, Using Perspective

What you will need: either charcoal on newsprint, or black pen on white drawing paper. Begin all of the following exercises with a 1″ margin drawn in pencil.

We'll start with imaginary scenes. This one will be a tree-lined roadway stretching from right in front of you to some distance away. Remember the exercise in perspective in the last chapter. Landscape can be drawn the same way. As the road moves away from you its lines come together at the most distant point on your horizon. Draw such a triangle so that it looks like a big mountain on your paper. Continue the lines (using very light or dotted lines) into the opposite corners of the paper so that you have a drawing that resembles an envelope.

Now divide the original triangle into near, middle, and most distant areas. Be sure that the nearest area is the largest, the middle area is mid-sized, and the most distant is the smallest. Use light or dotted lines to divide the space. The spot at which your two triangles meet is called the *vanishing point* on the horizon. The dotted lines of the upper triangle will indicate to you how big to make your trees. Next draw four or five trees, on each side of the road; the largest is the nearest, the smallest is the farthest away from you. Use the top guidelines to get the heights of the trees right. The two closest trees should be so large that you can't see all of them.

This exercise will include two rules of perspective: that the most distant point is where the lines come together at the vanishing point, and that things look smaller when they are farther away.

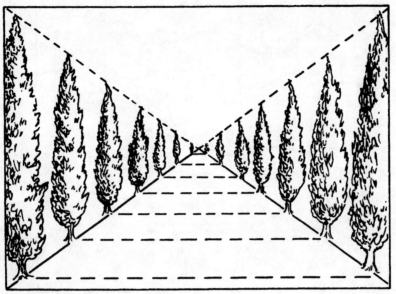

Ex. 1: Tree-lined road

EXERCISE 2 Empty Landscape: Finding Areas of Space

What you will need: pen or pencil on white paper, using a thin line. Pencil margin.

This will be an empty landscape—no trees or houses or other objects. Imagine yourself on a vast western plain. Hold your paper horizontally. Divide the paper into three strips (very lightly). The nearest and biggest area will be the *foreground* (at the bottom of the paper). The middle area will be less big, and the most distant area will be shallow, just as in Exercise 1.

Now use long, simple wavy lines—four or five of them—to show: mountain in the distance, the farthest edge of the "middle" ground, the nearer edge of the middle ground, and a simple roadway or river in the foreground.

These lines do not have to be straight, nor do they have to be realistic. You shouldn't add any objects. With these few lines you will have an "empty" landscape, but its spacial areas should be clear to you. You should now find placing "things" in a landscape easier. This horizontal dividing of the picture gives a feeling of space or distance that you can't get by beginning with the objects themselves.

42

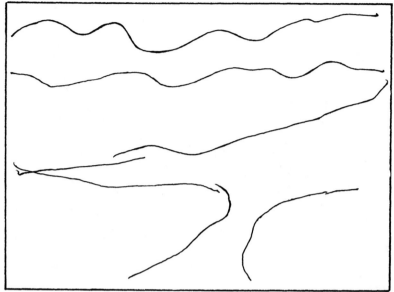

Ex. 2: Empty landscape

EXERCISE 3 A Simple Landscape in Continuous Line

What you will need: heavy pen on drawing paper, or charcoal on newsprint. Begin with a pencil margin of 1″.

Now, using a heavier line, do the same drawing as Exercise 2, but *without removing* your pen or charcoal from the paper. This should be one continuous line moving horizontally and again dividing the picture into several roughly horizontal areas that give you near, middle, and distant areas, as before. Try to make your line interesting, using different shapes, curlicues, thicknesses of line, etc. Include mountain shapes, shoreline shapes, rock-pile shapes, or whatever you think of.

When you have made a long continuous line that you like, add two or three objects to your landscape. These objects can be related to your drawing: a small black boat near the shoreline, a tree in the field, etc. The *pattern* or design of your line makes this picture interesting and suggests the theme of your drawing. It should also show you that what you see can be simplified into *abstract* shapes and patterns.

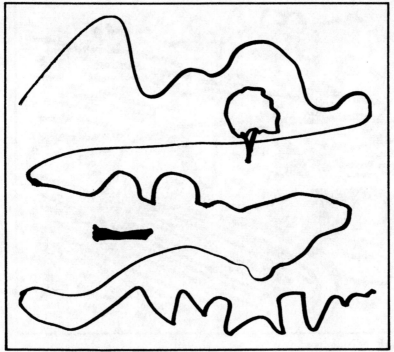

Ex. 3: Simple landscape in continuous line

EXERCISE 4 River Landscape in Short Decorative Lines

What you will need: Heavy black marker on white paper or charcoal on newsprint. Make a 1″ margin in pencil.

The look of landscape drawing can be completely different depending on the kind of line you use. Quick, short strokes of your pen or charcoal can describe a scene so that it looks very different from the one made with the long continuous line. These short lines can suggest direction and *texture* (the surface of the area such as rippling water, growing grass, brickwork) as well as make your drawing bright and decorative with patterns.

Begin by lightly drawing in your areas of space, again including areas that are near, middle, and far away. Now fill in each area with a variety of patterns, and accent important lines by making them heavier and blacker. Add the same two objects to the landscape that you added in Exercise 3, but not necessarily in the same place.

44

Ex. 4: River landscape

EXERCISE 5 Rural Landscape More Realistically Drawn

What you will need: Use a fine-point pen or pencil for your first try at this drawing. Additional tries can be in any media you like. Don't forget the 1″ margin.

You are probably wondering when you'll get down to drawing what you see. This exercise can be drawn from nature, from a photograph, or from your imagination. Those of you who have the opportunity should go outdoors and begin drawing what you see. The theme is a rural one. It should include at least one house, some fields, some trees, and any other features you wish. (If you go outdoors to sketch, please check the instructions for choosing a good sketching spot in Exercise 8.)

If you use a photograph, choose one that is clear and has a feeling of distance and large areas. In other words, don't use a close-up of one house or one tree. If you are drawing from imagination, make sure that you design a landscape that includes large distances.

Begin with guidelines of space areas as before, making horizontal divisions on your paper, as in Exercise 2. Now place

the major objects (houses, big trees, mountains, roads) in each area as in Exercise 3. Next use your line to add details of surface, pattern, and direction as in Exercise 4. Your fine line should make it easy for you to add details such as wires, fences, and flowers. These details should come *last*. Remember this is a picture of an *area*, not one particular house or tree.

Ex. 5: Rural landscape

EXERCISE 6 Closer Landscape—
An Urban Scene

What you will need: fine point on white paper.

You've probably noticed that so far all of these exercises have been scenes that are rural, with large areas of space. But many landscapes are urban or cityscapes. You usually can't *see* the distance—instead you see lots of buildings behind one another. Yet every landscape has some kind of space. If you can't see the ground area surrounding the buildings, you have to find a different way of showing that one thing is behind another or farther away. Diminishing the sizes as you did in Exercise 1 only works when you have a large open area, like a roadway to set the objects against.

The simplest way to show space in this kind of picture is once again to think of the picture as having a foreground, a middle, and a most distant area. Each building you want to include has to be placed in one of these areas. Obviously, those in the background will be partly hidden by those closer to you, and they will appear quite flat, like posters or giant billboards. Those in the foreground will have three-dimensional qualities like the houses you drew in Chapter I. (Try standing four books on end, one behind another, but each one visible to you. Notice how the nearest books look three-dimensional, while the farthest appears flat.)

For this exercise you can draw an imaginary city scene, one from a photo, or a real city. It should include many buildings, perhaps a factory, or a collection of houses very close together. A visible street will help you, but it isn't necessary. Make the buildings in the nearest area three-dimensional. Make the buildings in the middle area only slightly three-dimensional. Those in the background should appear quite flat. Remember, you won't be able to see the bottom of the most distant buildings.

EXERCISE 7 Untraditional Landscapes

What you will need: your choice of media.

Many twentieth-century artists are less interested in traditional landscape and realistic ideas of space. While they may make pictures that suggest a landscape, often the spatial areas are deliberately confusing. In the next two drawings you can experiment with some less traditional ideas about showing landscape. For example: if the buildings that are supposed to be behind one another are tipped slightly, will they express depth? If distant things are drawn in as much detail as closer things, and are the same size, will they still look farther away? If there is no angle to the roadways or other lines that usually emphasize depth, will there still be distance?

Try some of these problems yourself. One exercise is to divide your picture into seven or eight roughly horizontal sections, and fill each with a different landscape pattern—flowers, rocks, ocean, trees, etc. Make each section equally interesting, whether you think of the top of the picture as the most distant or not. Do you have space? Is there a good design? Is it a landscape?

Another exercise in untraditional landscape drawing is to think of your urban picture as very simplified. Make only four or five buildings and tip them in different ways like a handful of playing cards. Experiment with black accents. Do you have distance? Is one building behind another? Think about some of these ideas as you begin drawing real landscapes, or when you look at contemporary art.

Ex. 6: Urban scene

Ex. 7: Untraditional landscapes

EXERCISE 8 Outdoor Sketching

What you will need: The best materials to take outdoors are a spiral sketch pad, several #2 pencils, and an eraser. Loose paper tends to blow around, so a pad is better. Pen is sharper and more dramatic, but unless you are already a skilled artist, you will want to do some erasing. Any drawings done in pencil outdoors can be reworked indoors with any media you choose.

Now that you're ready to try outdoor sketching, you should be careful to choose a scene that has the makings of a good composition. It should not be too busy, such as a highway full of moving traffic, or a playground filled with equipment and children. On the other hand, it shouldn't be an empty scene either, like a vast field of growing corn. It should have some feeling of space, whether it is just a road with houses on each side, a winding river, or different areas of fields and fences. If you are in a city, work in a park area, where the surrounding buildings can be a good addition to the design. Choose a scene that is simple enough to draw clearly; it can have trees or buildings or both, but such things as flower gardens, clothes on lines, and parking lots are very hard to simplify for this exercise.

After choosing your spot, sit down with your pad in front of you and as high as possible. (Try not to draw leaning way over because your arm will not be free enough.) Now imagine that you have a camera lens and have to limit the amount you can include in the picture. Choose your most distant spot (and stick to it), deciding that it will be the farthest area in your drawing. Now, without drawing anything, find the middle ground and pick out the most important features of it, noticing where they are in relation to the rest of the scene. Now decide what you will include in the foreground. Eliminate small details as you look. Remember, you can't start a landscape by drawing an elaborate picture of a tulip or a parked car.

Now begin to draw by marking down lightly the three areas of space. Next choose several important lines to start with, such as roads, hills, walls, or other major divisions of the space. (Don't start with one building or tree and try to fit everything else around it—you'll find that you don't have room for the other things. Your picture will lack an overall design because you didn't plan it as a total picture.) Now place several important vertical lines in your drawing; they can be a church steeple, a tree, a bridge support, etc. These should guide you in placing other things.

Work all over all of your picture, not just in one section. Don't try to finish one area at a time. If you need to, measure the relative sizes of things by closing one eye and holding your pencil up in front of you as if it were a ruler. How far up on the pencil does the tree go? What is its relationship to the hill behind it? As you get used to sketching you'll see these relative sizes more and more easily without measuring, but this is a good way to learn. After you've completed the major parts of your drawing, you can add as much detail as you like.

OPTIONAL

When you've completed your picture (which may take several outings) you can go back to your classroom and do it again in another medium, or add details to it. Use the original for placement and accuracy. Add any kind of ornamentation or pattern you like, or use it as a model for drawing in one long, continuous line, or in many short, broken lines. Try making an abstract design from your sketch, using only the patterns and lines.

FOR DISCUSSION

The following is a collection of landscape drawings by master artists. You will see that there are many different ways to draw a similar scene and to show distance and space. Notice the kind of line each artist used, and see what it adds to the feeling of the drawing. See if you can identify the different aims of the artists. Did each want his or her picture to be as true to life as possible? Did they all use perspective?

Master Drawings

23. *Drawing* by Charles-François Daubigny

24. *Montagne St. Victoire* by André Masson

How do these two artists show distance in their landscapes? Which lines are used for decorative effect or pattern, and which indicate the dimensions of the scene?

25. *The Washerwomen* by Vincent van Gogh

What technique does Van Gogh use to show the flowing waters of the river and the fields of grain? How does he show distance?

26. *Landscape in the Département of L'Orme* by Edgar Degas

How is Degas' drawing organized? Does he use the same techniques as Van Gogh used?

27. *Ships in the Harbor* by Henri Mattise

How does the ornamental line unify this drawing? Is there distance?

28. *Untitled Drawing* by Wols

What sort of line does this artist use? How does it make the drawing interesting?

29. *Tiber Landscape with Rocky Promontory* by Claude Lorrain

How does the artist's choice of media affect the drawing? Would it look the same, or have the same impact, in line instead of brushwork? How do the light and dark passages create distance?

30. *Kult-Statte* by Paul Klee

Is there distance or depth in this drawing? Is it a landscape? Why or why not?

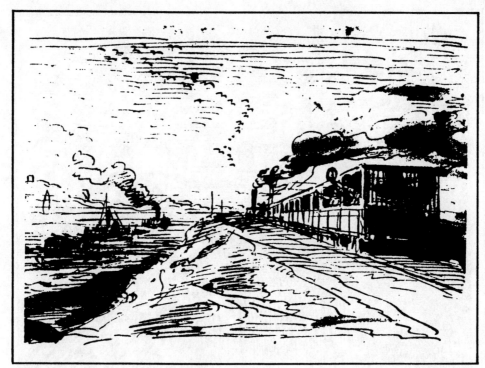

23. *Drawing*, Charles-François Daubigny

24. *Montagne St. Victoire*, André Masson

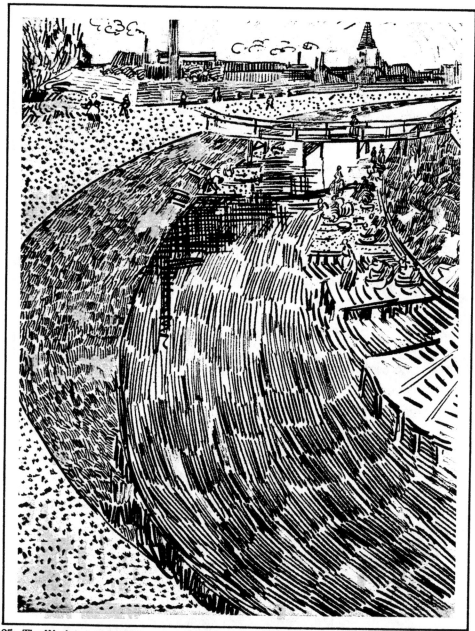

25. *The Washerwomen,* Vincent van Gogh

26. *Landscape in the Départment of L'Orme,* Edgar Degas

54

27. *Ships in the Harbor*, Henri Mattise

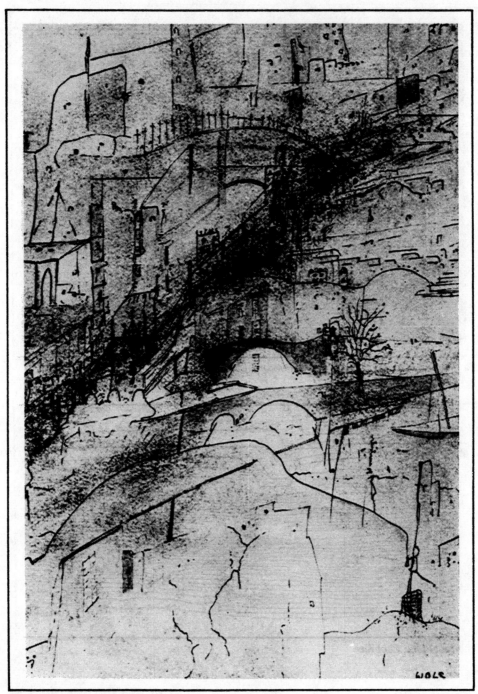

28. *Untitled drawing,* Wols

56

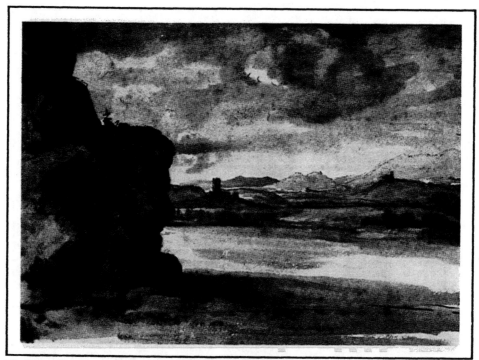

29. *Tiber Landscape with Rocky Promontory,* Claude Lorrain

30. *Kult-Statte,* Paul Klee

Chapter IV

Trees: Different Ways of Seeing the Same Thing

Everyone knows how to make a drawing of something you'd recognize as a tree. Often you see a child's version of a tree: a trunk with a round ball on top. A tree without leaves is simplified as a letter "Y" with an extra branch sometimes. But few trees actually look like these simplified shapes. If you want to draw a tree as it really looks, you have to begin by *seeing* it as it really is. A leafy tree is seldom perfectly round, nor perfectly *symmetrical* (equally balanced), and what is often drawn as a straight trunk is usually a knobby irregular shape. Branches do not match exactly, with one opposite the next. In this chapter we'll try some ways of drawing trees so that you can express the different shapes and forms and details, rather than just a "symbolic" tree that could be any tree, anywhere.

Artists have different aims in drawing any natural form, including trees. One artist may want to capture its *form* (or three-dimensional shape), while another might want to show the details of the leaves and the patterns they make. A third artist may be interested in the idea of trees in a general sense, showing patterns of light and shadow, and simplifying the details to the most basic shapes and lines. Another might want as realistic a representation as possible. Each artist has a particular way of *seeing* the tree, and the style of his or her drawing reflects different aims. There is no single "right" way to draw from nature because you are not a camera. You must simplify in some way what you see, and what you choose to put into your drawing.

Choose a tree with leaves to draw (not an evergreen). If you can see a full leafy tree from your window, far enough away so that you can see all of it, use it as your model. If not, get a good photo of a leafy tree. If you can make outdoor sketching trips, that's even better.

EXERCISE 1 The Simplest Tree: An Outline

What you will need: media of your choice.

The simplest way to draw anything is to make its outline.

Look at your tree carefully. What is its outermost shape? How large are the leafy areas in relation to the trunk? Draw the outermost line and don't include any details. Add a line showing the ground. This drawing will be recognizable as a tree, but what does it lack? Two major things are missing: it has no three-dimensional form, and it has no detail (leaves, branches, etc.) so it looks like a flat cutout. Nevertheless, it says "tree" in a direct, childlike way.

EXERCISE 2 The Symbol of Tree, with Leaves

What you will need: black marker and white or colored paper.

A symbol is a sign that brings you a message. A tree symbol "says" tree, without being a particular tree. If you make an outline as in Exercise 1, and add some branches and leaves, will it be a specific tree? Try it. Working from memory, make a simple black tree trunk and add some branches. (Make your drawing large enough to fill the space of your paper.)

Add leaves on all the branches, wherever you can fit them. Obviously, these leaves are not exactly where the leaves would be nor are there enough of them to be realistic. The average tree has thousands of leaves. Nor could you see the shape of each leaf fully. Your drawing gives you the *idea* of a tree, however, and anyone can recognize what it is. This is the style many *primitive* (untaught) artists have used, and the results are often decorative and charming, rather than realistic.

EXERCISE 3 Detailed, Fine-point Tree

What you will need: pen or sharp pointed pencil and white paper, not newsprint.

This time try to draw the tree in Exercise 1 more carefully. Begin by making the trunk and the major branches, being sure of *directions*, that is, the "lean" of the trunk and each branch. Trees generally do not grow straight up, and their branches usually curve. The accurate drawing of nature is the most common aim of most people who draw, and you should *look* at the tree over and over again. Don't try to "fix" it in your mind, and then spend a lot of time drawing from memory. Your eyes should constantly turn to the tree to see if you are getting an accurate picture. (Some artists work with their eyes entirely on their subject, seldom looking at the drawing at all. Try it!)

Ex. 1: Outline

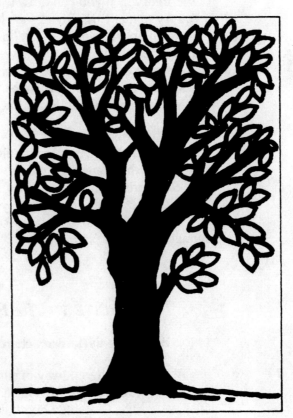

Ex. 2: Symbol of tree

After you have the trunk and the branches placed, lightly sketch in the overall areas of leaves. You will have to simplify what you see. To do this, squint your eyes at the tree, eliminating most of the detail except the strongest branches. Once you have the overall shape and the important lines, use the ornamental line of your fine point to suggest smaller details, such as twigs and leaves, where you see them most clearly. Work within your network of branches.

Remember, the amount of small detail you use should be less important than the basic angles, lines, and shapes of the tree. Of course, you know your drawing won't include *every* twig, and every leaf, and will therefore not be totally accurate. But that is the artist's job: to filter through the details of nature to make a personal choice of what will make a good drawing.

EXERCISE 4 The Leafy Tree Again

What you will need: media of your choice, including mixed (or combined) media.

Another way to be more "specific" is to focus on one part of the tree, which you can draw with more realistic detail than if you try to make the whole tree. In Exercise 3 you should have been able to get the "lean" of the tree and its branches, but you couldn't include the leaves as they really look, nor each branch and twig. If you focus this time on one or two near areas of the tree, drawing them as accurately as possible, you can *suggest* that the rest looks the same.

In other words, choose a few of the closest branches. Catch the way the leaves look individually and how they are attached to the branch. Be careful to get the drooping or leaning characteristics of these "up-close" branches. Then sketch lightly the rest of the tree behind your detailed areas. This is one more way to *see* something complicated and to simplify it enough to make a picture of it.

EXERCISE 5 The Form of Trees

What you will need: charcoal and newsprint pad.

An entirely different way of simplifying what you see is to look for its three-dimensional form. Trees, like houses, have sides and backs, width and depth. Finding those dimensions is

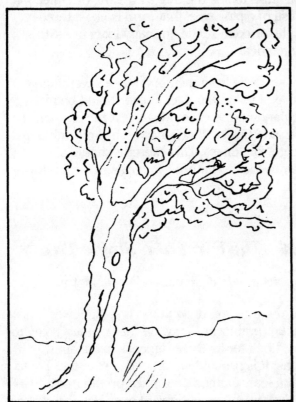

Ex. 3: Detailed, fine-pointed tree

Ex. 4: The leafy tree again

not hard once you learn to see the tree as a form, or collection of forms. In the case of a pine tree, that form is like a three-dimensional triangle, or cone-shape. In many leafy trees, the form is rounded, spherical.

For this exercise, draw from memory. Make several large shapes with the side of your charcoal. These should be big, rounded or triangular, and they should suggest the *sculptural* form of leafy trees. Add trunks. Blacken the sides of each large form to help indicate roundness. This exercise should show you a different way to look at nature—in terms of form rather than detail.

EXERCISE 6 The Form of a Single Tree

What you will need: charcoal and newsprint pad.

Look again at the tree you drew in the first exercises. This time look for its sculptural form—imagine that you are going to make a statue of it. Look for its three-dimensional shapes. Begin with the trunk. It is probably a tall cylinder shape. Try to find the forms in the leafy clumps that make up the tree's shape, as though they were large lumps of clay. Use the side of you charcoal to show shadows or roundness of form.

Compare your drawing with Exercise 1; notice how your latest drawing has a sculptural form compared to the flat two-dimensional quality of your first. While it lacks the detail of Exercise 2 or 3, it gives you a more basic picture of the form of that tree, so that if you were to sculpt it you would know its basic dimensions.

EXERCISE 7 Combining Techniques

What you will need: media of your choice.

Using the ideas of all of these exercises, draw your tree again so that it has form, detail, and beauty of line. You can use a combination of media, but you might want to begin drawing in charcoal or erasable pencil until you have the proportions right. Now experiment with different media to express the texture, shapes, characteristics, etc. of the tree. This is a "free" exercise, and it can be done many times or only once, so long as it combines both the techniques and ideas you've been working on. This is a good opportunity to try new combinations of media.

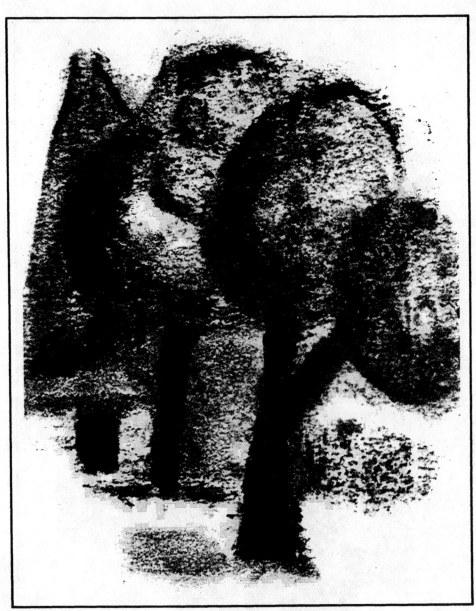

Ex. 5: The form of trees

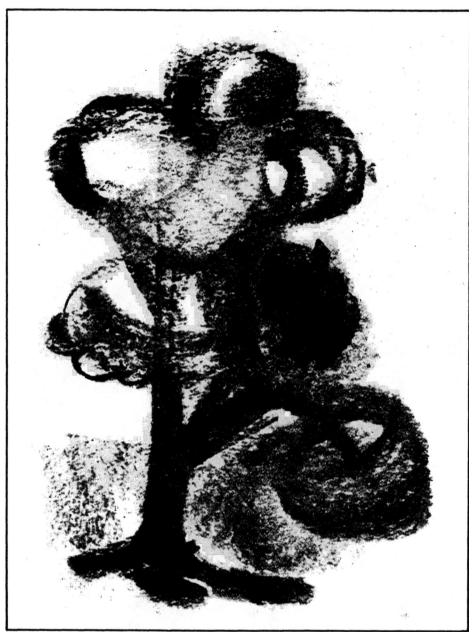

Ex. 6: The form of a single tree

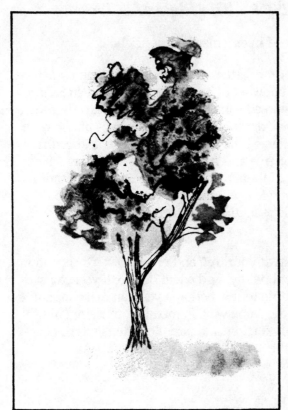

Ex. 7: The form of trees

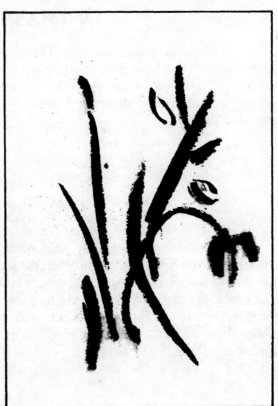

Ex. 8: Idea of a tree

EXERCISE 8 The Idea of a Tree

What you will need: media of your choice.

Some contemporary artists have chosen to simplify nature instead of trying to show all of its details. As we saw in Exercise 2, primitive artists worked with the "idea" of a tree, rather than drawing a specific oak or elm. Modern artists have also turned to a similar idea, reducing the complex to its simplest terms. If you take a particular tree and reduce it to its most basic lines (perhaps five or six of them), you can suggest a tree without detail. Sometimes one leaf will indicate that there are thousands of leaves. This reduction of nature to its "minimal" form is worth trying too.

Look once again at your tree and choose five or six important lines. Make them boldly. Add a leaf or two. If you can see the tree in these simple terms, perhaps you can make an entire drawing of a forest the same way. Remember, these are all good ways to draw nature, each expressing the different personality or aims of the artist.

OPTIONAL

This is a good time for the first showing of your drawings. Photograph the tree you have used as a model (or use the photo that was your model). Mount it on a large poster board, and then present this series of completed exercises to show the different ways of looking at, and representing, a tree.

FOR DISCUSSION

The following drawings by master artists should give you an idea of the wide variety of their aims and objectives. Try to identify the media and the kind of line used (detailed and ornamental, hazy and deliberately unclear, sculptural, very simplified, etc.). Discuss which drawings have the most feeling of natural conditions like wind, sunlight and shadows, and which show the most interesting form in a more abstract sense. Which are the most realistic?

Master Drawings

31. *Elms in Old Hall Park* by John Constable

 How did this artist combine an interest in form and detail?

32. *Cardinal Climber* by an anonymous artist from India

 How did the artist's choice of media make this drawing realistic? What are some of the things you know about this particular plant from the drawing?

33. *Landscape* by Jean-Baptiste Corot

 Is this drawing realistic? Is there as much detail? Is there more or less "personal expression" in this drawing?

34. *Trees Along the Seine* by Georges Seurat

 What did this artist consider the most important part of the trees? How has he simplified nature?

35. *The Tree of Confession* by an anonymous English artist

 Why could you call this a "symbolic" tree? Do you think the artist made this drawing "from" nature? Did he include all of the leaves and branches?

36. *Apple Tree* by Piet Mondrian

 How has this 20th-century artist used nature? Is this a particular tree, or an apple tree "in general"? What do you think was the artist's objective?

37. *Fishing in the Melting Mountain* by Tani Bucho

 How did this Japanese artist use media to express form?

38. *Cypress Avenue at Villa D'Este* by Jean Honoré Fragonard

 Is this artist more interested in the specific leaves and branches or in the overall shape of the trees? How has the use of shadow helped him show the dimensions?

68

39. *Cypresses* by Vincent van Gogh

What do you think was most interesting to this artist about these trees? Was it their form or the lines of their trunks and branches or the pattern made by the leaves?

40. *Sunrise II* by Arthur Dove

How is the 20th century interest in form, rather than realism, shown in this drawing? How does the artist use light and shadow?

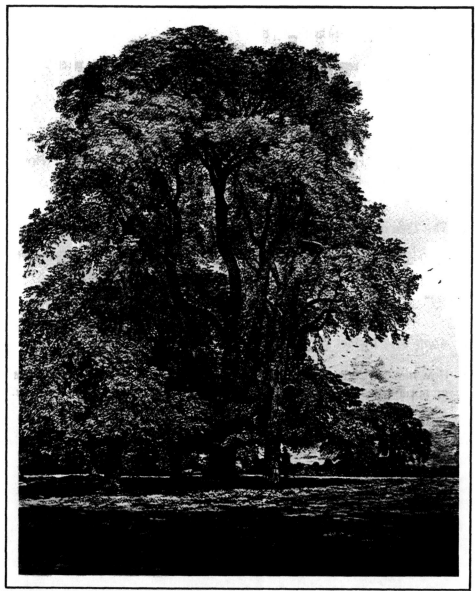

31. *Elms in Old Hall Park*, John Constable

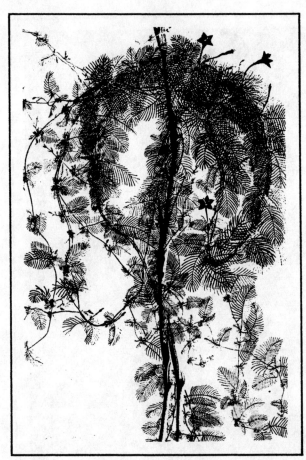

32.
Cardinal Climber, Indian, circa 1800

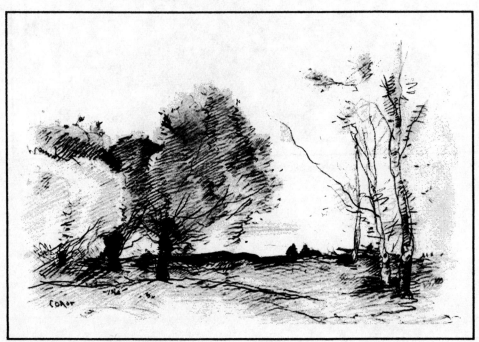

33. *Landscape,* Jean-Baptiste Corot

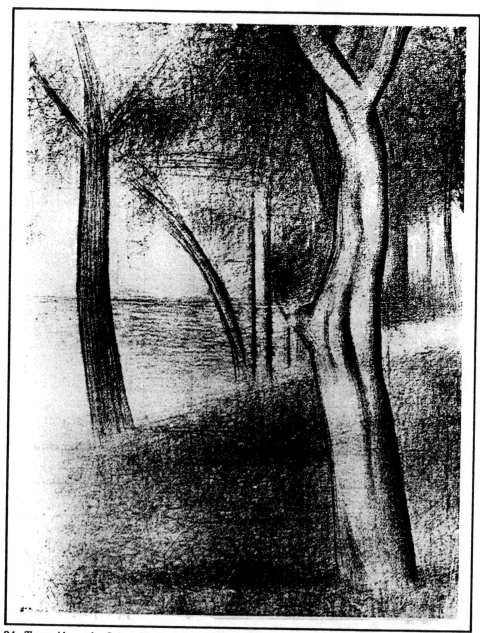

34. *Trees Along the Seine,* Georges Seurat

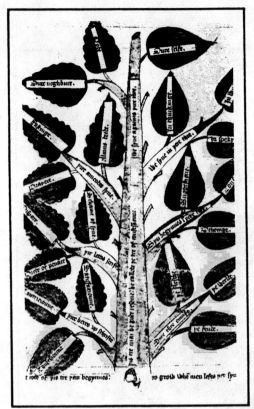

35. *The Tree of Confession*, English, circa 1425-1450

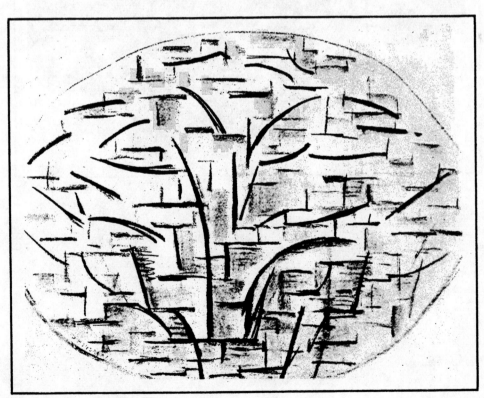

36. *Apple Tree*, Piet Mondrian

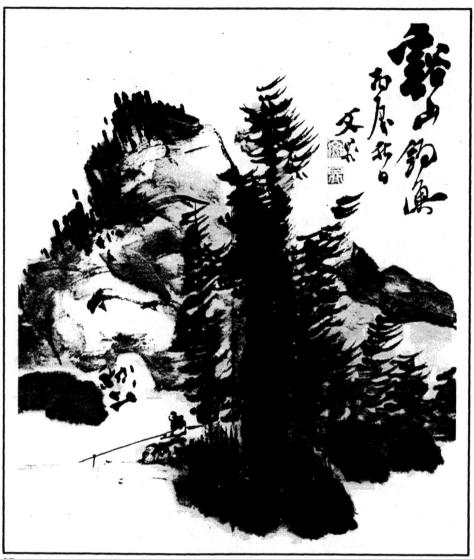

37. *Fishing in the Melting Mountain,* Tani Bucho

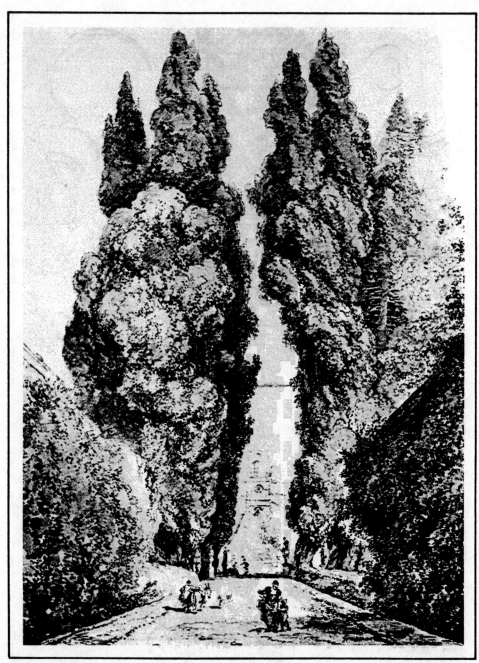

38. *Cypress Avenue at Villa D'Este,* Jean Honoré Fragonard

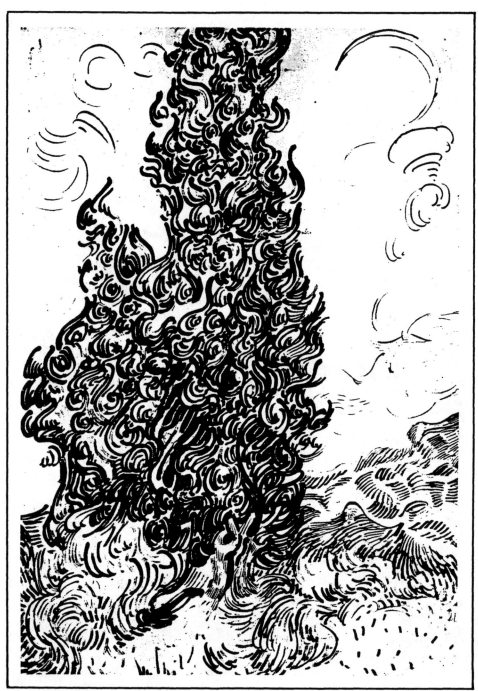

39. *Cypresses,* Vincent van Gogh

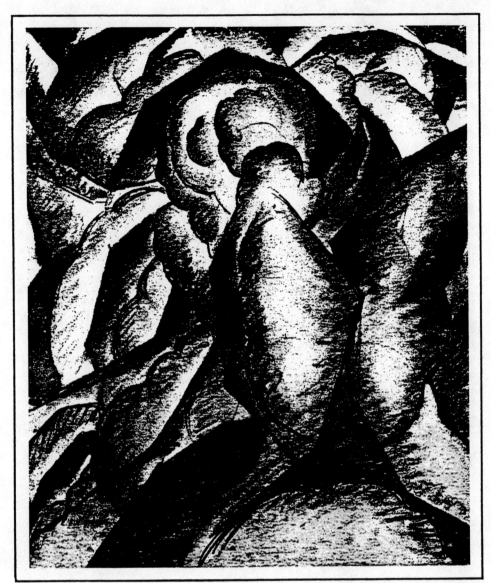

40. *Sunrise II,* Arthur Dove

Chapter V

Apples, Bottles, and Guitars: Drawing Still Life

Artists call a picture of a collection of objects a *still life*. The objects can be vases, bottles, dishes, flowers, fruit, musical instruments, or any other items placed in an arrangement on a table. The table is sometimes covered with decorative cloth or paper. Why draw objects? The most important reason is that artists find the relationship of different objects together in a still life beautiful. A still life can offer a great variety of shapes, forms, colors, and patterns. Rather than searching out a scene in nature, artists can set up their own collections of objects to draw, and can place them in designs they like. They can draw the same setup many times, because changes in the artist's position and in the light will make the still life look a little different each time.

Learning to draw objects accurately means you'll learn to show the three-dimensional quality of objects, or their *volume*. And when you draw the objects in still life, you learn how to show the space around them. In the following exercises you'll learn how to give an object volume, how to use shading, and how to place the object in a particular area.

To begin you'll need a table that is easily visible to all. Choose several bright-colored sheets of large construction paper. Push the table against a wall, and then hang two pieces of colored paper on the wall behind the table. They can be tipped, and they can overlap. The table should be low enough so that you see all of its surface. Place the last piece of construction paper on the table. For the following exercises you'll need some objects: the first few require a large jug or vase, and an apple.

EXERCISE 1 *The Outline*

What you will need: Place the jug on the table on top of the piece of construction paper. Place the apple in front of the jug. Work in pencil, charcoal, or pen, on large paper, using the whole surface of the paper for each drawing.

The simplest way to draw an object or two is to draw their outlines. Begin with the table. The table, simplified, looks like a giant staple: it has a top and two visible legs. The jug also has a basic outline (rounded) and probably a handle on one side. Draw the outline. Next draw the outline of the apple in front of it. Your drawing should look very simple. What is wrong with it? The apple probably looks like a big hole in the bottom of the jug, or like the entrance to a tunnel through it. Why? Because, though you may have drawn the shapes carefully, your drawing will lack two important qualities: space and volume. In other words, you can't tell from your drawing where the objects are in relation to the space around them, and you don't see them as three-dimensional.

EXERCISE 2 The Table Surface

What you will need: same as Exercise 1.

The first improvement you can make is to draw the surface of the table on which the jug and the apple rest. Everything has a particular place—in this case the objects are on top of a piece of construction paper on a table. In order to find that particular spot, begin with the table top. Think of it as the top of a big flat box. Next draw the construction paper. Now place the jug exactly where it goes on the paper. Erase the line of the table behind the jug. This drawing should have a greater sense of space than your first one, because the objects are placed in a specific area.

EXERCISE 3 The Surroundings of the Objects

What you will need: This time remove the jug and the apple, leaving the empty table and the construction paper. Add one more piece of colored paper to the table, and one more to the wall behind. Use charcoal or magic marker on white paper for this drawing.

Draw exactly what you see. Begin with the table, making sure that you have its full shape (as in the top of a cube), and the beginning of the table legs. Draw the papers on the wall. Add the papers on the table, being careful to get the proper sizes and relationships. Next black in the darker areas. When you have all of these areas accurately drawn in size, shape, and angle, you'll have a better idea of the space your objects will occupy.

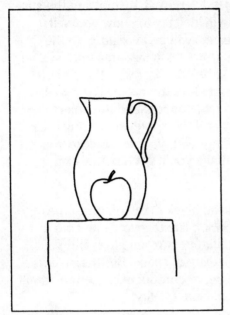

Ex. 1: Outline

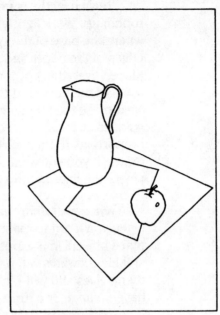

Ex. 2: Table surface

Ex. 3: Surroundings of the objects

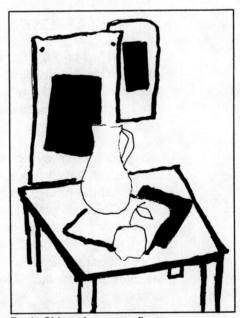

Ex. 4: Objects in surroundings

EXERCISE 4 The Objects in Their Surroundings

What you will need: Return the jug and the apple to
the table, placing them on top of the construction paper and in
front of the hanging sheets of paper. Use charcoal, heavy pen
and ink, or magic marker on white papper.

Begin exactly as you did in Exercise 3, by drawing the surroundings. Work lightly, using guidelines to show yourself where the base of the two objects will be in relation to the edges of the paper and table. Don't fill in any area until you've placed everything properly. As before, start with the dimensions of the table and the papers hanging on the back wall. Next make the table legs and table papers and the object guidelines. Finally add the jug and the apple, measuring their proportions to their surroundings with your eye before you draw. (If you squint at the still life you'll get a better idea where the lines belong.)

When everything is in place, black in the darkest areas. Once you learn to make a drawing like this you'll be able to place objects in a variety of different surroundings, and your still life drawings will have a feeling of space. But the objects themselves still will look like paper cutouts because they don't have *volume*, or a three-dimensional quality.

EXERCISE 5 *Volume of Objects*

What you will need: Place either a basketball (or other ball that is divided into segments of equal size) or a peeled orange on the table. Add a thick book, or a box shaped like a thick book. Place the two objects side by side. Use charcoal and newsprint pad.

In order to draw an object's volume, rather than just its outline, you have to look at it more carefully. How do you show that the orange is round *all the way around*, not just in outline? How do you show that a book has depth? Begin with the box or book shape. In Chapter I you learned to draw the cube, using lines that show depth, width, and length. Draw the book the same way. Now shade in the side that is away from the light. You are using two ways to show its volume: lines and shading.

Rounded objects are harder. While the cubelike dimensions of the book can be clearly shown with lines and shadow, it is more difficult to divide the rounded object into top, bottom, and sides. But look at the basketball or orange. In each case there are some lines to guide you. The orange (or the ball) has equal segments. But notice how those segments appear. The segment in the middle seems wider, while the others get narrower and narrower as they reach the edges of the ball. Each segment seems to bulge at the center and get thinner at either end.

Using the segment shapes as your guidelines, draw the object. If you squint at it, you'll notice that the side farthest from the light is the darkest. Shade in the segments that look darkest to you. Follow the rounded shapes of the segment lines as you shade. Now make the lightest (unshaded) area the spot where the light hits the object; grade the other segments from dark to light. Does your orange have volume?

Of course all rounded objects are not divided into clear segments, and when you draw them you will have to imagine or *see* those divisions yourself. (Don't move on to Exercise 6 until you understand this one.)

Ex. 5: Volume of objects

EXERCISE 6 Volume of Objects, continued

What you will need: Add to the other objects such items as a jar, a basket, a vase, a cup, etc. Place the objects so that you can see at least three objects clearly. Draw only one object at a time. Use charcoal and newsprint paper.

In drawing these more complicated objects you should use the same ideas. Try to see the basic forms and shapes in each object. Find the bulging parts and the flatter parts. Use light guidelines to show where the object is at its fullest or roundest. Shade the darkest sides. Try several objects, always noticing form and volume. Add a shadow on the table, shading lightly the area that looks the darkest. (The shadow should match the side of the object that is darkest.)

As you become more skillful, drop the guidelines and work more freely, shading more heavily and using your charcoal eraser to whiten the lightest areas. Remember to work large; the objects should be drawn almost life-size.

Ex. 6: Volume of objects, continued

EXERCISE 7 Three-dimensional Objects in the Still Life

What you will need: Set up a still life again. Place two or three objects back onto the construction paper on the table. Add a piece of cloth or a curtain in the background for variety. Let it hang freely to one side, making some dark shadows with its folds. Work in charcoal on newsprint paper.

Now we'll combine the exercises of this chapter. Begin by "setting the stage" for your still life. Draw the table, the background, and the pieces of construction paper *without the objects*. Using light charcoal lines, set out the position of the objects. Measure each one against the background for size and position, not with a ruler but with your eye. Lightly draw in the outline of each object. Make sure you get the proper relationship of object to object: how big is one next to the other? Which is closer?

When everything is in place, squint at the setup. Find the darkest areas, whether they're on the table or part of the background. Shade in those areas, including shadows left by the objects. Accent lines that you feel are most important by drawing over them heavily. Compare your drawing with your first still life drawings. Does it show both space and volume? (This exercise of course can be done over and over from different angles, and with different objects.)

Ex. 7: Three-dimensional objects in the still life

EXERCISE 8 Detailed Line Drawing of Still Life

What you will need: fine-point pen or pencil and drawing paper. Set up your own still life this time. Think about interesting sizes and shapes, but keep it simple. (Don't choose objects that have huge size differences.)

If you know how to show space and volume, you are ready to go on to drawing in more detail. In this drawing you'll be focusing on design, pattern, and detail. But you should begin with the same ideas above, positioning everything carefully before you begin to draw any details. Using fine point, work on making this an interesting design using the pattern of the fabric, the shadows on the objects, the grain of wood, the design on pottery, etc. for interest.

Work slowly and carefully, and since you can't erase, make tiny guidelines to go by. Use a variety of lines, delicate shading, and details that interest you. Explore your own ideas. Try to discover how you like to draw. Your own style is important and you're free to follow it once you've learned the basic techniques for drawing accurately.

Ex. 8: Detailed line drawing

EXERCISE 9 Abstracting Still Life

What you will need: still life of your own design, media of your own choice. (Suggested: pastel chalks, charcoal, and newsprint paper.)

The object of this final exercise in still life is for you to explore ways of using still life to lead you into making more *abstract* art. Still life can give you a collection of shapes and patterns that you can turn into something quite different. For example, you've been using shading to show what you see: you darkened areas that *looked* darker. But what if you move from nature into imagination, and darken areas just to make an exciting design? Modern artists have done just that.

Some use the combination of shapes and forms and make them into designs that don't relate exactly to what they see. Others use repeated patterns of printed material (like newspapers) for their design. Abstracting from still life is worth trying if you like to use your imagination.

Try viewing your setup from much farther away, and including more than the table in your drawing. Or perhaps you want to try the reverse; drawing an extremely close-up picture (almost as if you were looking through a microscope). Instead of making the darks and lights as you see them you can try making an abstract pattern of darks from the still life. (See diagram.) You can try simplifying the lines to leave only a few, and instead, repeat a pattern of textures that you like. Experiment!

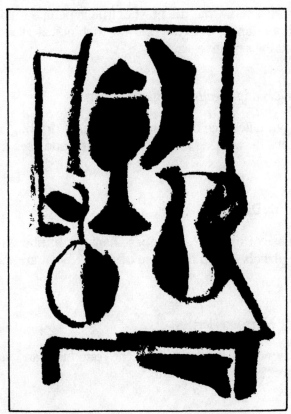

Ex. 9: Abstracting still life

OPTIONAL

Still life sometimes has a theme. You can set up a *theme still life* (sports, the "twenties," the world of music, etc.) by choosing objects that relate to your theme. (You can use such theme pictures to announce a

school event.) *Drawing flowers*, another popular form of still life, is not as easy as it looks. Get a vase of fresh flowers if you want to try it. Be careful to plan your composition, so that the full vase and flowers fit in. Remember, each flower has a particular shape and texture. You should try to put at least a few accurately drawn flowers into the picture, even though the tangle of their stems and leaves will be less precise.

FOR DISCUSSION

Master Drawings

41. *Still Life 1918* by Juan Gris

How does the artist show that the bowl of fruit is behind the wine glass? What are the important lines in the drawing that indicate space around each object and their relative sizes?

42. *Baskets of Flowers and Weeds* by Ogata Kenzan

What is the major difference between this Japanese drawing and the preceding still life drawing? Is there space? Which one uses a more decorative line?

43. *Still Life* by Morris Davidson

What are the uses of shading? How does shading contribute to the volume of the objects and to the sense of space? What are the lightest areas?

44. *Bowl of Fruit* by Marsden Hartley

In this picture how does the artist show the roundness and volume of each piece of fruit?

45. *Open Window with Pedestal Table* by Pablo Picasso

How does the artist make the surroundings of the objects just as important as the still life itself? Is the still life setup the only major part?

46. *Still Life* by Henri Matisse

How does this still life differ from the others? How has the artist simplified—what did he leave out? On the other hand, what details does he include that do not appear, for example, in the previous drawing? How does the artist's decorative line give you his impression of this still life without all of the traditional characteristics?

47. *Kitchen Still Life* by Janos Balogh

How does this artist use line? What are some of the ways his scribbly style defines volume, space, light and dark, the folds of drapery, etc.?

48. *Still Life* by Georges Braque

In this more abstract still life, what do you think were the artist's aims? Why do the repeated patterns add interest? Can you tell what is in front or back? Is there traditional space?

41. *Still Life*, Juan Gris

42. *Baskets of Flowers and Weeds,* Ogata Kenzan

43. *Still Life,* Morris Davidson

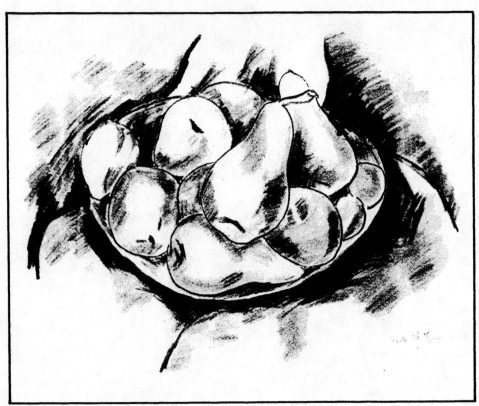

44. *Bowl of Fruit*, Marsden Hartley

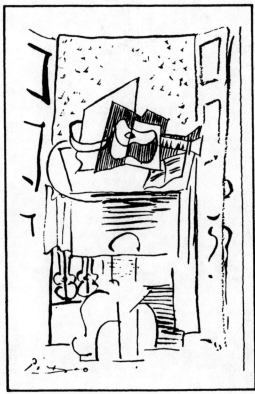

45.
Open Window with Pedestal Table, Pablo Picasso

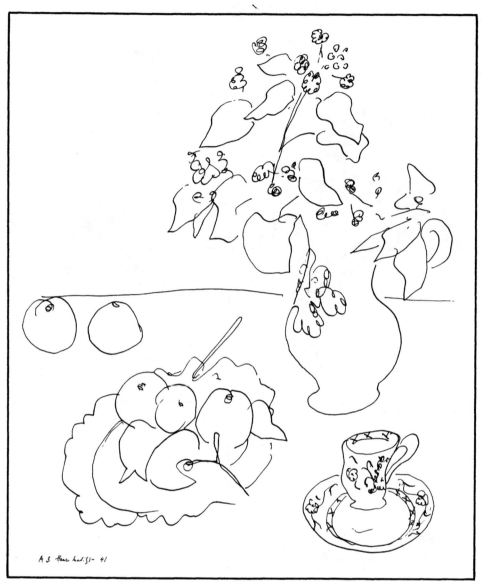

46. *Still Life*, Henri Mattise

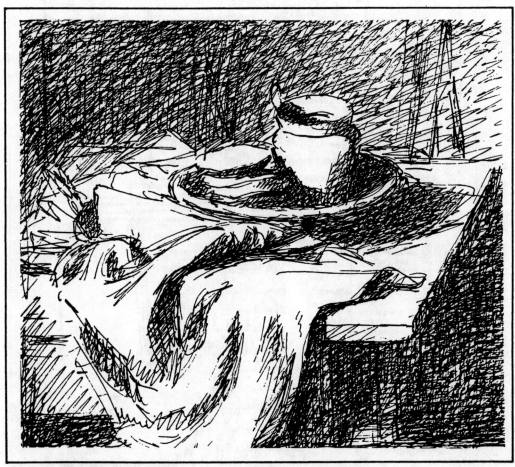

47. *Kitchen Still Life,* Janos Balogh

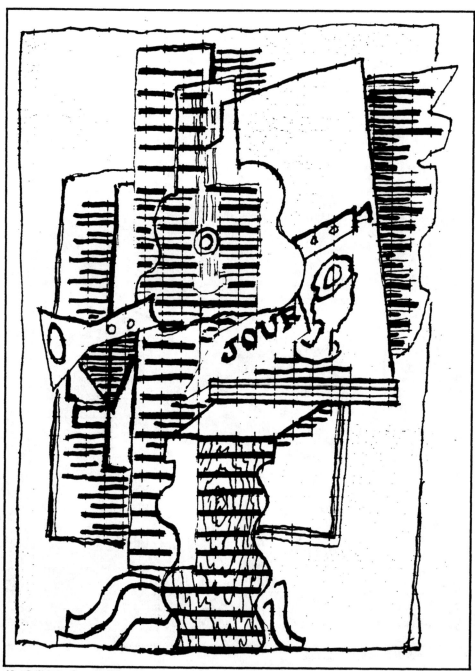

48. *Still Life*, Georges Braque

Chapter VI

People: Drawing the Human Figure

Drawing people is not as hard as it looks. There are several important things to remember before you start. The first is that you should work from a model; draw yourself (with the help of a mirror) or another person. The model can wear whatever he or she likes. (If you have the chance to use a professional model, that's better still, but not essential.)

The second thing to remember is that you should learn to draw the human figure by drawing *all* of it, beginning with the center of the body. If you start with the head of the model (the way children do), you'll have problems fitting in the rest of the figure, and getting the proportions right.

Next, remember that just as in landscape or any other kind of drawing, you have to *see* the form of the figure before you try to draw it. Try to find the three-dimensional shapes in the object you draw—in this case, the human body. But unlike other subjects you've drawn, the body moves. This means that each part of it can take different directions. You have to look for the *directional lines* showing the position of each part of the figure. You'll find that there are simple shapes, forms, and directional lines *in any position* the body takes.

The body is made up of some basic forms that you will work with: the head (an oval), the neck, the body between the shoulders and the waist, the hips, the arms and legs, and the hands and feet. None of these forms can be left out of your drawings, even if you simply indicate them in a general way. Since each of these parts of the body can move differently, the accuracy of your drawing will depend on your *seeing* them as forms that attach to one another. Though some of the greatest drawings of the human body look the simplest, with just a few dashing lines, don't be fooled. The artists studied and understood the basic forms of the body before they were able to draw so simply. Your first step is to learn the proportions of the different parts of the body.

All drawings should be large, filling the page. Do NOT draw small, cramped figures. And do NOT start at the top of the page. Always begin somewhere in the middle so that you can fit in all of the drawing.

EXERCISE 1 Standing Figure: Getting the Proportions Right

What you will need: Your model (boy or girl) should stand straight before you. It helps in drawing the figure to have the model stand slightly above floor level, perhaps on a low platform or on a pile of books. Use charcoal and newsprint pad.

Look at the model. Don't start with the head. Find the vertical straight line through his or her body. It should begin at the top of the head and end at the feet, dividing the body in half, vertically. Draw that line roughly on your paper. Now judge the placement of the three major sections of the figure. Begin in the middle of your line with the *torso* (shoulders to bottom of hips). The legs should be just about the same length as the torso. Draw three horizontal lines crossing your vertical line, indicating where the shoulders will be, where the waistline will be, and where the legs will begin.

Now make another horizontal line to show where the feet will be. Add the neck and the head. (Don't forget the neck; many people find it hard to remember the neck, and set the oval of the head directly on the shoulders.) The size of the head and neck together should be about one quarter as long as the rest of your drawing. (In fashion drawing these proportions are exaggerated so that the legs are sometimes five or six times as long, but they are not drawn for accuracy.)

The torso is divided about two-thirds of the way down by the waistline and the beginning of the hips. Using the waistline as a guide, place the elbow joints in your drawing; they should come at about the same place. Find the spot just above the middle of the leg for the knee joints and make a small guideline. Now with these horizontal guidelines for help, lightly sketch in the outlines of the whole figure. Your drawing can be very rough.

Don't be surprised if your drawing doesn't look exactly like the model. This is just a preliminary exercise to show you the proportions of the body. Remember that these proportions *do not change* if you turn the body sideways, upside down, or any other way. (The only way they'll change is in relation to your view of them; sometimes you'll see your model from a particular angle which will make the body *appear* to be foreshortened or out of proportion.)

Ex. 1: Standing

Ex. 2: Stick figures

EXERCISE 2 The Stick Figure

What you will need: Your model will have two different poses for this exercise. First, he or she will stand directly before you, feet slightly apart, arms and legs slightly bent. After you draw that pose, the model will stand in a running position, with his side to you. Use charcoal and newsprint or pencil and pad. Work big.

Everyone knows what a stick figure is—the simplest way of drawing a figure. It may look childish to you, but it is useful in pointing out the directions and lines of the body. Begin by drawing the model as before, facing you, but draw only the directional lines. Make sure the length of each line is as accurate as you can get it. Make the legs and arms out of two separate lines each, to show the joints.

Next place the model sideways to you, in a running position. Again draw him (or her) as a collection of sticks or short lines. These simple drawings will show you two things: the *proportions* of the body and the use of *directional lines* to find the position of the different parts.

EXERCISE 3 Large Forms

What you will need: Ask your model to pose for just a few minutes at a time in a variety of positions, sitting or standing. Use charcoal and newsprint.

Try to see the body as a collection of basic shapes—triangles, circles, boxes. Look at the model carefully before you start to draw. Imagine that you're working with big lumps of clay. For example, look at the shapes made by the model's back, arms, legs, and stomach. Raised knees might look like a triangle. The shape of the back or stomach might be oval. Draw quickly, doing several sketches of each pose. Learn to see the body as a collection of large *sculptural* forms, as if you were beginning a sculptured figure.

Ex. 3: Large forms

EXERCISE 4 The Body as Rounded Forms

What you will need: Ask your model to pose in a position of running. Use charcoal (or pencil) on newsprint.

This time try to see the body as a collection of rounded shapes. Begin with a lightly drawn stick figure, making the proportions accurate. Think of the stick figure as the center line of each part of the body, and then draw *rounded* shapes suggesting each segment of it. The legs, for example, will be made up of an oval for the thigh, an oval for the calf, and another circular form for the foot. The hips will be circular; be careful that

you get the direction of that form right. (Remember, the hips are a separate section from the upper torso.) Make each rounded form the appropriate size—the circle of the foot shouldn't be the same size as that of the torso. Try to *see* the body as a collection of rounded forms.

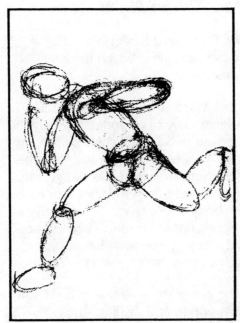

Ex. 4: Body as rounded forms

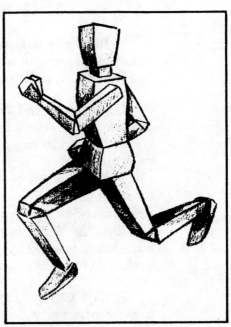

Ex. 5: Body as boxes or cubes

EXERCISE 5 *The Body as Boxes or Cubes*

What you will need: Place the model again in a running position, and use charcoal and newsprint.

Now try to see the body another way: as a collection of geometric shapes like boxes or cubes. Think of each part as a small or large box, with three dimensions. Begin with the torso, a large boxlike form. The hips will be another box, sitting in a different direction. Each leg will be made up of two long boxes, one for the thigh, the other for the calf.

Before you begin to draw these cubic forms, make a skeleton figure with accurate proportions. Use the guidelines of the skeleton as the center of each box shape. Try to make the backs and sides of each box correctly, just as if you were drawing the house in Chapter I. Use the side of your charcoal to shade some of the darker sides of each box to accent the three-dimensional quality. These exercises should show you

that the body is not a one-dimensional or two-dimensional shape, but a collection of three-dimensional forms, both round and geometric.

EXERCISE 6 Action Lines

What you will need: Place your model in a sitting or crouching position, or any other position in which the limbs and back take a variety of directions.

Use charcoal and newsprint pad and work *large*. In this exercise you can use a lot of extra lines. Use your arm freely. Look at the model and make your usual small guidelines for proportions: check where the legs begin, where the torso begins and ends, where the elbow and knee joints should go, etc. Now look at the model and try to determine the angles or directions of each part of the body. Using as many lines as you like, draw the directions or action lines you see. (They will basically follow your stick-figure skeleton, but don't forget the neck, the change of direction at the waistline, even the feet.)

Don't erase anything. The aim of this exercise is to get you to draw more freely and easily and to find the lines that express movement. Most of your lines will be straight, but you can fill in between the action lines with rounded forms if you want to. Try this exercise several times, changing the model's position. Work fast.

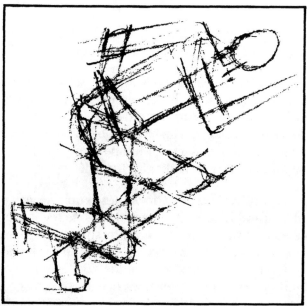

Ex. 6: Action lines

EXERCISE 7 Realistic Drawing of the Figure

What you will need: Ask your model to sit on a stool or chair in a position that is comfortable enough to hold for some time. Use charcoal or pencil on newsprint.

Now try to combine some of the ideas of the exercises you've completed. Begin, as in Exercise 1, with tiny guidelines to get the proportions right. Next, as in Exercise 2, make a light stick figure of the sitting model. As in Exercise 6, make your action lines next, being sure that the angles of the back, legs, arms, neck, hands, and head are accurate. (You can leave these guidelines or erase them later. Eventually you'll learn to draw without them, but they are helpful at the beginning.)

Next look for the major forms of the body, as in Exercise 3. Lightly sketch in the rounded forms of the body and limbs and head, as in Exercise 4. Look at your model and identify those areas that would make up the back or sides of each form if they were boxes or geometric shapes, as in Exercise 5. Use shading if you want to.

Your completed drawing may look very "worked over" to you, but it should have the accurate forms and shapes of your model. If you practice drawing the figure this way over and over, you'll soon be able to drop some of the first steps. If you find that your drawing looks flat or out of proportion, go back to the earlier exercises.

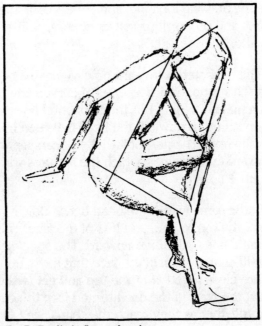

Ex. 7: Realistic figure drawing

EXERCISE 8 The Head

What you will need: charcoal and newsprint pad.

Before you can draw a portrait that looks like the model, you have to learn to get the position and form of the head and face. While we won't go into portrait drawing or "likenesses," we can experiment a bit in drawing heads. Begin with the *axis* of the head. This means the straight line downward from the top of the head, between the eyes, dividing the nose and mouth and ending in the center of the chin. No matter how the head turns or tilts, there is always a straight axis, though it isn't always vertical. This line is always at right angles to the other lines of the face: the line across from one eye to the other, the line at the bottom of the nose, and the line across the lips. Begin by drawing the face looking right at you, not tipped or turned at all. Make an oval. Since the face is looking straight ahead, make the axis straight up and down.

Cross the oval with the eye line, and then the base of the nose line and the mouth line. (See Diagram 1.) The eye line divides the oval in half. The nose line is halfway between the eyes and the chin. When you divide the space between the nose and chin into thirds, the mouth line marks the top third.

Now add the eyes on the top line, a simple nose and mouth, and ears fitting between the eye and nose guidelines. (Don't try to make it look like someone in particular.) (See Diagram 2.) These are the basic positions of the features. To make the drawing look *like* someone, you'll alter these basic features and proportions (fatter cheeks, pointed chin, larger eyes, shorter nose, etc.).

The next step is to learn how to make a head look up or down. This is done with a series of curved lines. The axis of the head remains straight. But the horizontal lines curve when the head looks up or down. If the head is turned up, less of the face will show. The part of it that you can see will contain downward curving lines, which the features will follow. (See Diagram 3.)

In the same way, if the head bends downward, it will show more of the top to you, and less of the face. This time the horizontal lines will curve upward. The spacing of the curving lines will change, too. In the face that looks up, the curving lines are close together at the top and get farther and farther apart at the chin; in the downturned face the curving lines get closer together as they reach the chin. (See Diagram 4.) These lines, remember, are guidelines. The experienced artist knows

they're there and doesn't have to make them, but the learner should use them.

Suppose the head is tipped to one side. In this case the axis is also tipped. The horizontal lines will still be at right angles to the axis, so they'll change too. Don't forget that the neck will not necessarily be tipped the same way. The neck and shoulders often have a different angle than the head. (See Diagram 5.) If you want to combine tipping the head with making it look down, you will simply combine the techniques of Exercises 4 and 5. In other words, your axis will be tipped, and the position of the features will follow the curving horizontal guidelines shown in Diagram 4. Notice the large amount of the top of the head you see in this position. (See Diagram 6.)

Try next to draw a head that is not facing front. In this drawing you'll have to show part of the side and back. Remember, even though the head is not a round ball, it is a three-dimensional form. You can show those dimensions much as you did drawing the ball or the orange in the last chapter. Like a ball, it can be seen as a series of segments, the face being the front section. To draw a face turned slightly away from you (but not in full profile), begin by making the overall shape with a curving axis for the face. You will also have curving horizontal lines for guidelines for the features. (See Diagram 7.) Be sure to include enough of the side of the head. Now add features, following your guidelines. Darken area of hair. (See Diagram 8.)

If the face is a full *profile* (sideways view) remember that most of what you see will not be the face, but the oval shape of the head. In general, that oval is wider at the face than at the back of the head. Begin with a horizontal oval which will form the top part of the head. Add another oval to suggest the part of the face you'll see. Join the two ovals along the chin line, up through the jaw line to the back of the head. (See Diagram 9.) When you have the shape of the head done, add the features. (See Diagram 10.) This should give you a more realistic profile than that usually drawn by beginners who forget that a profile includes the side and back of the head.

Our final exercise in drawing heads is again a profile. This time practice tipping the profile to look up or down. As before, use guidelines to find the right proportions. First make an axis line to indicate which way the head is tilted. Intersect it with guidelines to show you where the features go, remembering to make the lines at right angles to the axis. (See Diagrams 11 and 12.)

If you combine these exercises you should be able to figure out how to draw just about any position of the head. Once you have worked with these ideas you can try drawing from a model and begin to adjust the features and proportions to resemble him or her. Measure with your eyes the comparative relationships. Are the model's eyes larger than ordinary? Are

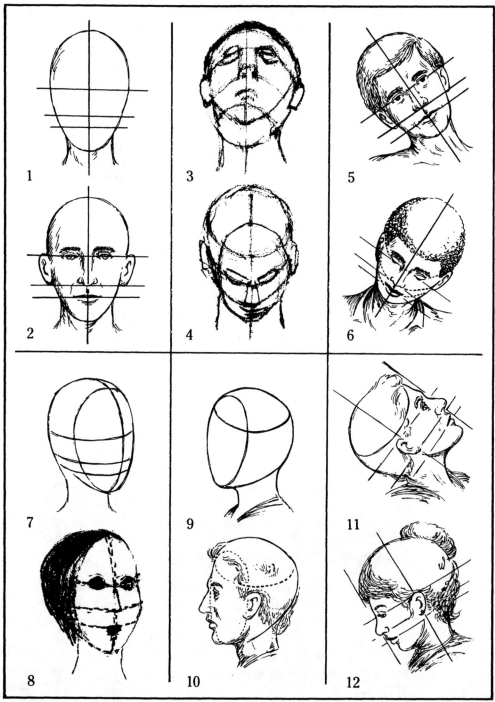

Ex. 8: The head

they closer together? Is his or her head shaped differently? Is there a very high forehead? A large space between the nose and mouth? (It is less important, however, to match the model's particular look than to draw the head accurately at this stage. When you've mastered the basics, you'll be ready to move on to portrait drawing.)

EXERCISE 9 Different Ways to Draw the Figure (I)

What you will need: media of your choice. The model can pose any way. (This exercise is only recommended to those who have mastered Exercise 7. It is not necessary for the course, and should be either optional, or for advanced students.)

Some of you may want to try other ways of drawing the human figure. These ideas are basic to 20th-century art and can make understanding contemporary art easier. And they are fun to try yourself.

Both of the following exercises are ways to simplify what you see when you look at the figure. The first drawing will be in line only, without shading. Study your previous drawings. Choose one of them, or copy one, and erase everything you can without losing the most essential lines. First try this with a charcoal drawing. Then turn to another media such as pen and ink, and make a fresh drawing that has the simplicity of your "erased" one. It should include only the most important lines. Use the particular qualities of your media for interest. But be careful that the proportions and forms are still accurately expressed.

EXERCISE 10 Different Ways to Draw the Figure (II)

What you will need: Same as Exercise 9.

The second of these two exercises is also a study in simplifying what you see. This time, instead of simplifying the *line*, try to simplify the *forms*, much as you did in Exercise 3. In that exercise you tried to find several large geometric forms in the body. This time try to find any variety of shapes (not necessarily geometric) that are made by the various parts of the body.

104

Use heavy blacks (ink or charcoal) to emphasize these forms and to make an interesting design. Simplifications such as these are basic to contemporary art, and perhaps you'll recognize these ideas in some of the artists' drawings that follow.

Ex. 9: Different ways to draw the figure (I)

Ex. 10: Different ways to draw the figure (II)

OPTIONAL

Working with clay can help you learn to draw the human figure. Using large lumps of clay, try to model the body without detail. Experiment with different shapes, sizes, and positions. *Work with a model posing for you.*

FOR DISCUSSION

In looking at the following drawings of the human figure by master artists, try to guess their goals (accuracy? decorative line? geometric forms? etc.). Compare the most abstract ones with the more traditional. What are the major differences?

Master Drawings

49. *Male Nude Kneeling* by Peter Paul Rubens

50. *Madam d'Hussonville* by Jean-Auguste Ingres

51. *Archer,* Venetian (circa 1600)

How do these artists achieve such realism? What techniques do you recognize? How do shading, perspective, and proportional measurements help make the bodies so realistic?

52. Drawing from *A Treatise on the Proportions of Humans* by Hard Schoen

53. *Caryatid* by Amedeo Modigliani

How do these two artists "see" the human body in these drawings? What basic forms do they put together?

54. *Scribe* by Japanese artist of 17th century

55. *Sketch of a Girl Sleeping* by Rembrandt van Rijn

56. *Dominique de Braga* by Dunoyer de Segonzac

What do these three drawings have in common—how does each artist use *line*?

57. *Woman Seeding* by Paul Gauguin

58. *Odalisque* by Auguste Renoir

59. *Three Men* by Jean Émile Laboureur

In what ways do these three works contrast with the last three? How do they resemble sculpture?

60. *Painter and Connoisseur* by Pieter Breughel (Elder)

61. *Angel's Head* by Leonardo da Vinci

62. *Study of George Moore* by Walter Sickert

63. *Head of Ezra Pound* by Henri Gaudier-Brzeska

64. *Black Head* by Pablo Picasso

Compare these five heads. What do you suppose were the different aims of each artist? Which might have been the best likeness? Which might have been the best "character study?" Which do you find the most interesting? Why?

49. *Male Nude Kneeling,* Peter Paul Rubens

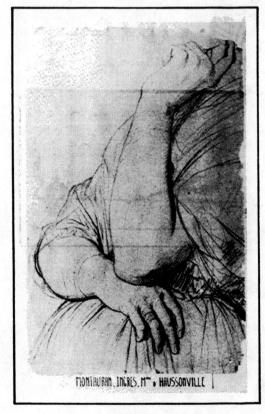

50.
Madam d'Hussonville, Jean-Auguste Ingres

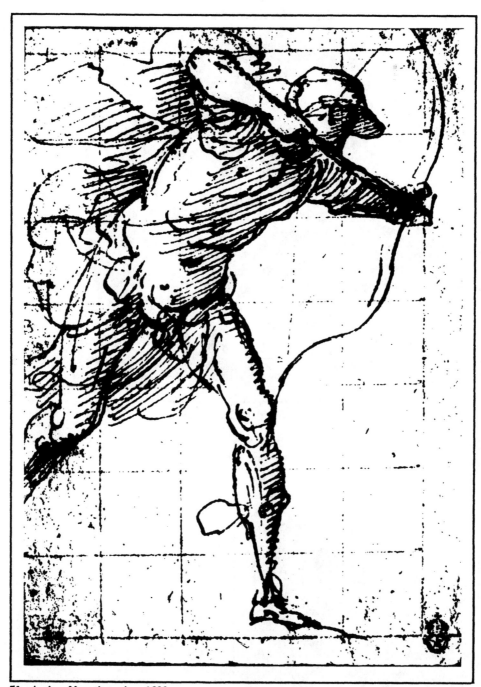

51. *Archer,* Venetian, circa 1600

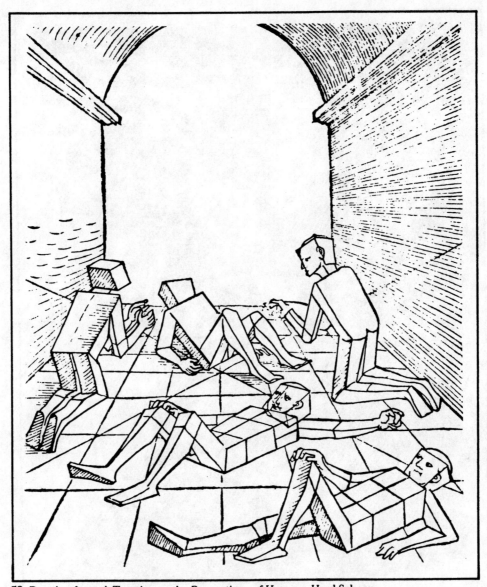

52. Drawing from *A Treatise on the Proportions of Humans,* Hard Schoen

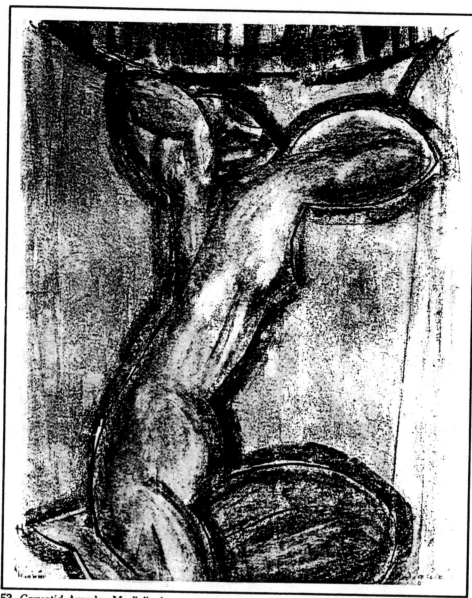

53. *Caryatid,* Amedeo Modigliani

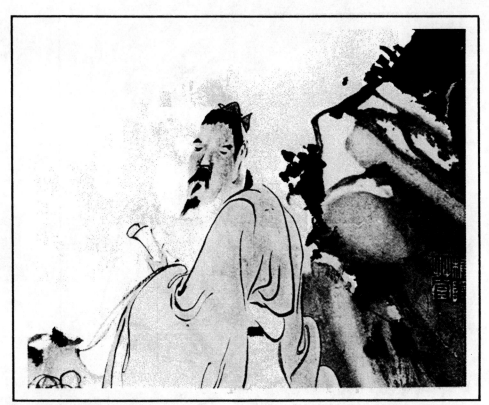

54. *Scribe,* Japanese, 17th century

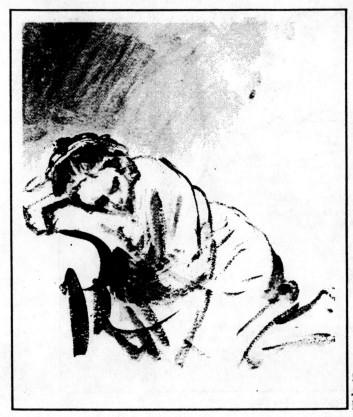

55.
Sketch of a Girl Sleeping,
Rembrandt van Rijn

DESSIN pour « 5000 »
de Dominique BRAGA
(Édition N.R.F.)

56. *Dominique de Braga*, Dunoyer de Segonzac

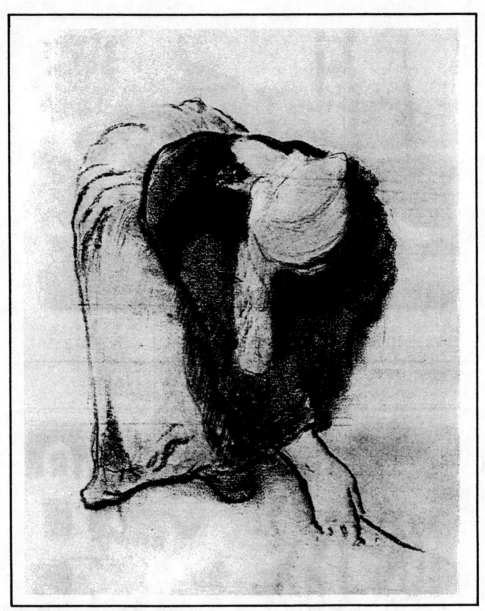

57. *Woman Seeding*, Paul Gauguin

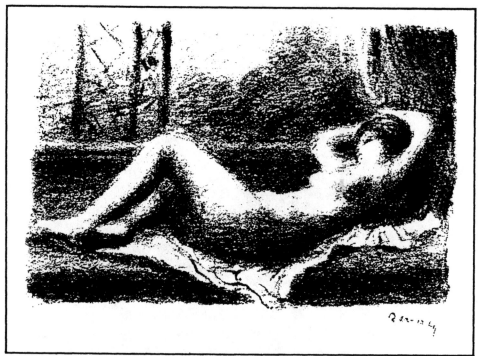

58. *Odalisque*, Auguste Renoir

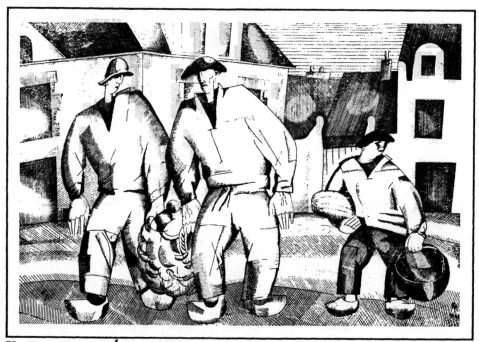

59. *Three Men*, Jean Émile Laboureur

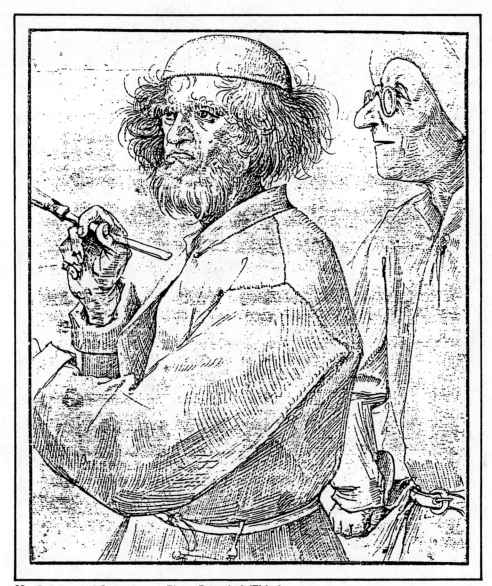

60. *Painter and Connoisseur,* Pieter Breughel (Elder)

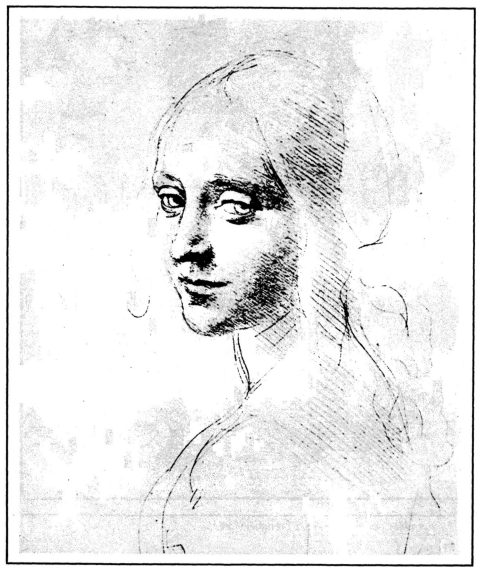

61. *Angel's Head,* Leonardo da Vinci

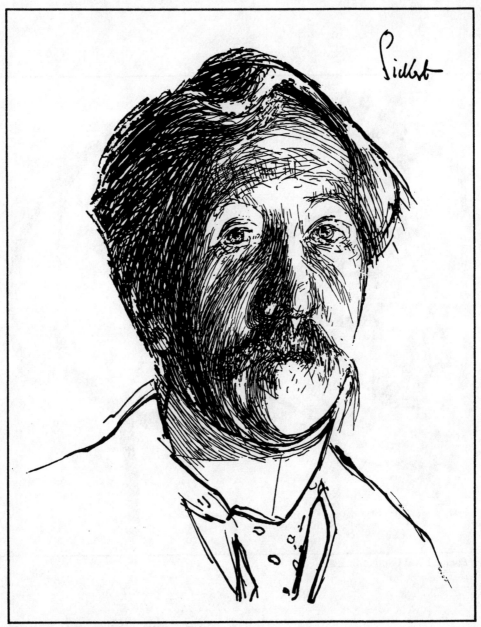

62. *Study of George Moore*, Walter Sickert

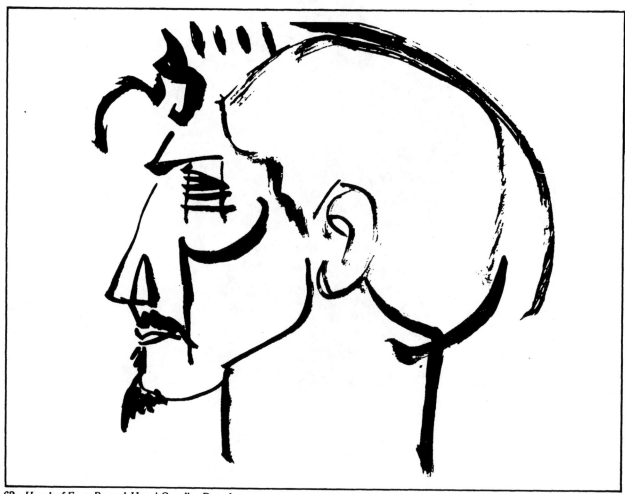

63. *Head of Ezra Pound,* Henri Gaudier-Brzeska

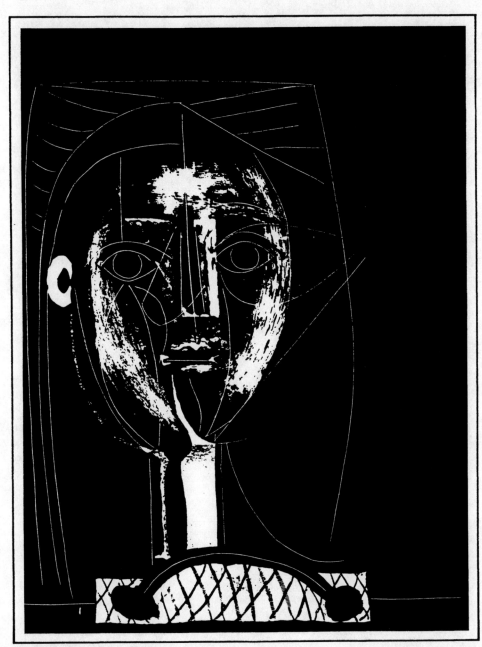

64. *Black Head,* Pablo Picasso

Chapter VII

Composition: How to Design a Picture

There is no right or wrong way to design a picture. If there were, all drawings would look exactly alike and you'd spend your time copying the great masters. The artist is free to use his or her creativity, to stress what seems most important, to leave out whatever he or she cares to, to make all sorts of personal choices.

But finished drawings (not sketches) do share certain elements of design, or what artists call *composition*. This is another way of describing the pattern or organization of the picture and how the various parts fit together. There are as many ways of doing this as there are individual artists. You'll make decisions about the composition of your drawing from the moment you choose a subject.

In the first place, you have to decide *how much* you want to fit into your picture, and *how close* the subject will be to you. You will have to choose the media, the size of the paper, and the style of line you want to use. Obviously, a thick heavy line won't be the right choice for a very detailed drawing, nor will a thin, fine, delicate line be the best choice for a very simple, bold drawing. There is no absolute rule about what to put into a work of art, but how much you choose to include will make a big difference to your composition. Just as a photographer looks through the square frame of his camera lens to position his subject, you will look at your subject and try to *see* it as an overall design.

In the next few exercises we'll explore ways to design a picture. Keep in mind the size of your paper; it should be well-used. (Don't use huge paper for a small detailed drawing, for example. Relate your media and the size of the paper to your view of the subject.) Remember that what artists call *negative space* (where nothing appears) is part of your composition too, just as silences in music or in plays are often as important as sound.

EXERCISE 1 How Much to Include, and What Size

What you will need: media of your choice.

Think of four things that go together: a house, a tree, a fence, and a sun; a bowl, a glass, a spoon, and a pitcher; a chair, a table, a lamp, and a book; or whatever four items you can draw easily. (Don't look at the diagrams until you've tried this drawing.) Place the four items in your picture. Do the drawing several times, varying the position of the items and their sizes. What is the best design? Everyone's will be different, but the most successful will use the space of the paper interestingly, and will in some way relate the items to each other. Look at the diagrams when you've finished.

Some of the pitfalls of design are shown in Diagrams 1 through 4. In Diagram 1 the four items appear in a row at the top of the page. They don't use the full dimensions of the paper, and they have very little relationship to one another. They might remind you of border wallpaper or children's writing paper. In Diagram 2 the four shapes appear in opposite corners. This makes for *symmetry*, a rather boring form of composition, in which everything is of equal importance and the corners are "weighed down." Again, the objects don't share the space together.

In Diagram 3, the four shapes are better related to one another, but the drawing doesn't make use of the space, leaving a mostly empty picture. While *negative space* is often interesting, it has to have a shape or design too, and shouldn't just be blank space surrounding your subject. In Diagram 4 on the other hand, the objects are so large that they overwhelm the space. If the artist liked the idea of doing a closeup of the front of the house, he might have used larger paper or made his drawing smaller. (Exaggeration of these ideas often appears in contemporary art. Twentieth-century artists have deliberately chosen some of these ideas to work with in a nontraditional way, and you'll get a chance to try them too, at the end of this chapter.)

Even if you plan to draw a very simple picture of only one thing, the composition you choose is important. For example, a single object can be very large, very small, centrally positioned, or over in one corner. In the next exercise try making a variety of designs involving only one object in different sizes and positions.

Ex. 1: How much to include and what size

EXERCISE 2 One Object in a Composition

What you will need: media of your choice.

Choose a single shape: a tree, a door, a vase, a chair, etc.
and make three different drawings, exploring size and position.
You can include two extra lines to make the position of the
object clear, or to draw the eye to the object, or to divide the
space.

Once you've decided what object to draw, how big to make it, and where to put it on the page, the next decision might be the design of your picture. How will you fill up the space? How will you divide the areas around your object? In Diagrams 5, 6, and 7, you can see pictures of a door in various positions; you can also see how the space is divided in each one.

In Diagram 5 the composition is made up of a large rectangle within the rectangle of the paper. In Diagram 6 the picture is basically divided into two horizontal halves. In Diagram 7 an important diagonal line divides the paper. And yet each is a picture of the same door. Experiment with this exercise until you understand the idea of dividing up the space of your paper in several different ways.

EXERCISE 3 Structures for Design

What you will need: pencil and paper or charcoal and newsprint.

In traditional art (particularly before the 19th century), many pictures were designed with a particular structure in mind. Sometimes these works were made in the shape of a triangle, a circle, a cross, or even a pyramid. Sometimes religious themes were pictured in the shape of a cross, and sometimes landscapes and still-life drawings were made in circles or other geometric shapes. (If you look at some of the artists' drawings that follow this chapter you might be able to identify the design shapes in some of them.)

Although such a structured idea is certainly not necessary for a good composition, it's useful to recognize these shapes and to see how they're made.

Lightly draw a large shape such as a triangle, circle, or diamond on your paper. Make it as large as you can. Design a picture that seems to fit naturally into that shape. Some subjects fit more easily into certain shapes; for example, rooms are often rectangular, sails are often triangular, etc. (See Diagrams 8 and 9.) In Diagram 8 the table and vase of flowers form a triangle. In Diagram 9 the sailboat and its shadow make a diamond.) Notice how important the lines of your geometric shape can be in setting up your composition. If you erase your original lines, can you still recognize the structure?

5

6

7

Ex. 2: One object in a composition

EXERCISE 4 Dividing the Areas of Space

What you will need: pencil and paper, charcoal and newsprint, or pen and paper. Make a margin of 1″ before you begin.

Most of you don't want to design your pictures in such a contrived way. You can think of other ways to design the space of your drawing. You can divide it into basic areas that are not necessarily geometric circles, pyramids, or squares. An

126

8

9

Ex. 3: Structures for design

10

11

Ex. 4: Dividing the areas of space

interesting design can be achieved with just a few lines. They will unify your picture and make it more interesting (and freer) than the formality of geometric shapes.

Experiment with simple divisions of your paper into interesting areas. Using only one long continuous line, divide up your paper (held horizontally) by making a line that touches

each side margin only once or twice. Make it an interesting line, with squiggles and curves if you wish, or sharp angles. The space on either side of the line should be interesting in shape and size. Now try the same experiment with your paper turned vertically, making the line touch top and bottom margins. (See Diagrams 10 and 11.) A line such as this can have many uses in your design; it can unify two separate items as well as make the space around them interesting.

EXERCISE 5 Using Lines to Unify a Composition

What you will need: same as Ex. 4. Make a 1″ margin before you begin.

Start this drawing by making two completely separated images of houses, trees, vases, or whatever you like. They shouldn't touch. (See Diagram 12.) Except for the fact that they are both the same subject, they will be unrelated in the picture. Now add two or three lines that help to relate them and also divide up the picture area into an interesting design. (See Diagrams 13 and 14.) There is no right or wrong way to do this; you'll know you have a good design if your eye moves around the page, rather than focusing on only one spot.

EXERCISE 6 Using Black Accents (I)

What you will need: ink pen (heavy line) or magic marker and paper.

Another way to add interest and unify a composition is to make some lines heavier than others. The addition of *accents* (heavier black lines or patterns of black) can be very exciting in a drawing. Accents, as in music, provide rhythm or movement so that the most ordinary scene is more dramatic and interesting to the eye.

Begin with two simple unconnected rectangular shapes. They should be large but shouldn't touch each other. Make one into a simple table or other piece of furniture, and the other into a window. (Or make the two rectangles into two simple houses.) Next add several lines (either straight or curving) that will connect the two rectangles and in some way divide up the space interestingly.

128

12

13

14

Ex. 5: Using lines to unify a composition

Now try using black accents to unify the design. Begin by making some of the lines heavier than the others. Blacken several areas of your picture, being careful to spread these accents around the picture. Avoid symmetry, or overloading one area with accents. Try to make them in a lot of different sizes (so they won't look like wallpaper). (See Diagrams 15 and 16.) Do this exercise several times with different themes and different distribution of the accents until you feel you know how to use black accents to make a good pattern.

<table>
<tr><td>15</td><td>16</td></tr>
</table>

Ex. 6: Using black accents (I)

EXERCISE 7 Using Black Accents (II)

What you will need: same as Exercise 6, including a 1″ margin.

Now you can try some less formal drawing with accents of black. Instead of beginning with rectangles (as in Exercise 6) make some freely curving, squiggly long lines on your paper, or one continuous line from margin to margin (as in Exercise 4). Now add a series of black shapes (boats, rocks, trees, clouds, etc.) which are well distributed. Avoid the design pitfalls we have discussed: don't line up the accents or make them all the same size; don't fill up the corners leaving the center empty, etc. (See Diagram 17: What's wrong with it?)

Feel free to express yourself and your own ideas. (See Diagram 18—this is one of thousands of solutions to this problem; don't copy it.)

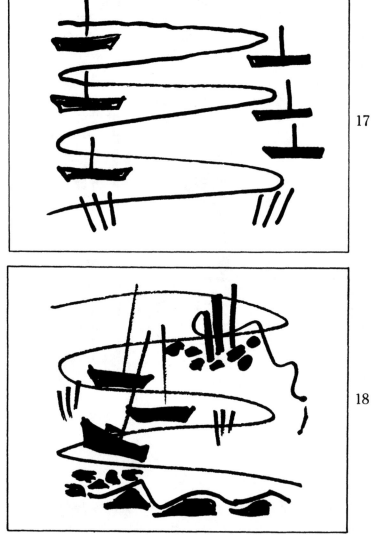

17

18

Ex. 7: Using black accents (II)

EXERCISE 8 Using Light Accents

What you will need: charcoal, charcoal eraser, and newsprint or black marker and paper.

Just as you used black accents in a white area to make your picture unified and interesting, you can use white accents on a black surface. Begin by distributing nine or ten small

shapes of any subject around the paper. *Just outline them.* They should be different in shape, size, and distance apart. Don't line them up in a row! Now use your charcoal (on its side) or magic marker to color in all around these white shapes. (See Diagram 19 for one example.) If you've accomplished this exercise well, you'll have a good design with no lines at all. (This exercise can also be done on scratch board.)

19

Ex. 8: Using light accents

EXERCISE 9 Experimenting with Design

What you will need: media of your choice.

While all of these exercises have been planned to teach you some of the basic concepts of design, there are lots of less traditional ways to organize a picture. In this century artists have explored everything from optical illusion (*op art*) to spattering ink and leaving the outcome to chance. Even if you prefer drawing what you see, you should try some of these concepts. Doing artwork that is totally *abstract* (without recognizable subjects) is good practice as well as fun, because you focus on the basics of what makes a good and interesting design.

Some of the drawing ideas you should try include: repeated line fragments, in which you make a short and interesting line and then use it over and over again; combining light and dark accents; working with ink blots, and working with geometric forms. You might also want to try doing extreme closeups of something you drew fully before, such as the cen-

20

21

22

Ex. 9: Experimenting with design

ter of a flower, or the arm of a chair. These experiments will show you that some of the ideas of design that you use in traditional drawing also appear in abstract art. (See some examples in Diagrams 20, 21, and 22.)

OPTIONAL

Experiment with cutting black and white shapes out of construction paper and placing them on large pieces of paper. This simple form of *collage* (pasting paper and other objects in a design arrangement) is good practice for learning how to distribute accents.

Another good project in design is to cut out examples of different kinds of design from magazines. These designs can represent the *symmetrical* (as in kitchen tile patterns), the repeated design (wallpaper), advertisements showing the tiny object in a giant space, to closeups with no surrounding space.

FOR DISCUSSION

The following pictures by master artists will give you an idea of the tremendous variety in design and composition that can be found in drawings. Consider carefully the use of lights and darks, position, and division of the space in each.

Master Drawings

65. *A Lioness* by Peter Paul Rubens

66. *Lion on the Prowl* by Antoine-Louis Barye

67. *Hunting Scene* by 16th century Persian artist

In these three compositions, look carefully at the placement of the lion. How does the relationship of the animal to its surroundings affect the viewer? Which is the most interesting in overall design? Which do you think has the greatest sense of space? Which is most realistic?

134

68. *Seated Figure of Juno* by Francesco Primaticcio

69. *The Day* by Odilon Redon

70. *A Castle Above a Lake* by Victor-Marie Hugo

In these three drawings the composition is built around a familiar shape. Can you identify the shapes? How has the artist accented the use of each basic shape within the drawing itself? For clues, look at the use of light and dark accents, and important lines.

71. *To Monte Alban* by Josef Albers

What do you think were this artist's aims? How did he use repeated fragments of line to achieve his striking result? (For a clue, follow one line section from beginning to end and see if it is repeated.) Does this composition have space?

72. *Christ Appearing as a Gardener to Mary Magdalen* by Rembrandt van Rijn

73. *Tree and Man* by Georges Seurat

74. *Drawing* by Leopold Survage

In each of these three drawings the picture area is divided with some important lines that make the composition interesting. Try to find those lines. Does the dividing up of the picture space like this only happen in modern art? Can you find other examples in this book?

75. *Encounter* by M.C. Escher

76. *Seascape* by Morris Davidson

77. *Asheville* by Willem de Kooning

In each of these three drawings the use of light and dark accents is very important to the composition. How are the accents distributed in each drawing? What has Escher (#75) done with the *negative space*? Is there any? Would #76 look the same in reverse, with the accents black on white background? How much of #77 do you think was left to chance?

78. *Four Figures in Space* by Oscar Schlemmer

See if you can identify the various ideas of composition and design in this drawing. Note the size and position of the figures, the division of the area into sections, the use of darks and lights, and the use of line patterns.

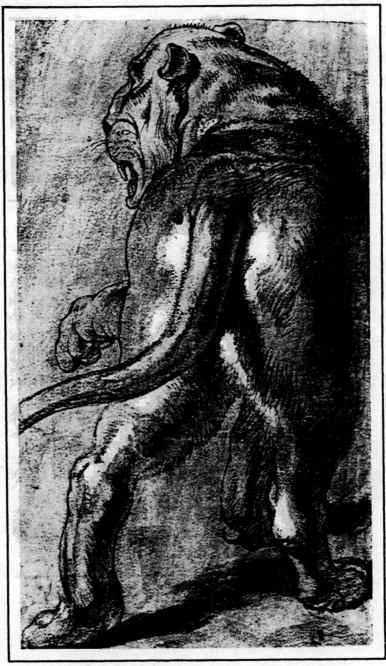

65. *A Lioness,* Peter Paul Rubens

136

66. *Lion on the Prowl*, Antoine-Louis Barye

67. *Hunting Scene*, Persian, 16th century

68. *Seated Figure of Juno,* Francesco Primaticcio

69. *The Day,* Odilon Redon

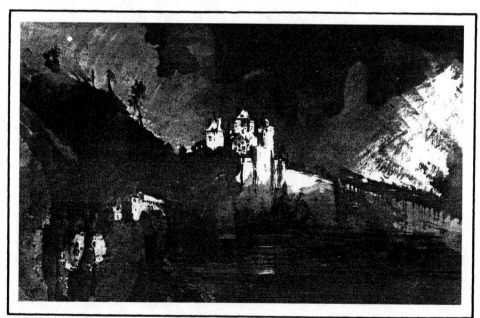

70. *A Castle Above a Lake,* Victor-Marie Hugo

71. *To Monte Alban*, Josef Albers

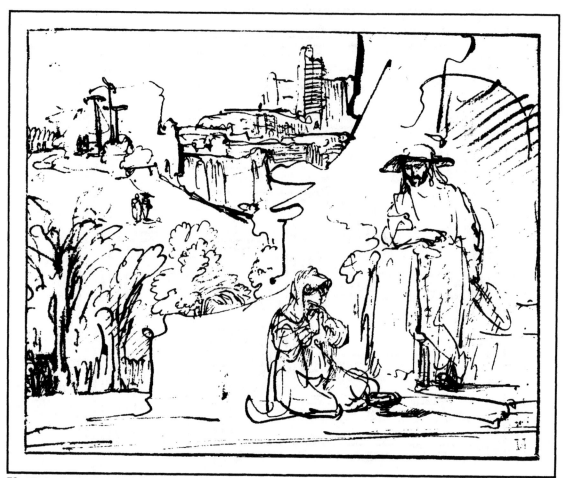

72. *Christ Appearing as a Gardener to Mary Magdalen,* Rembrandt van Rijn

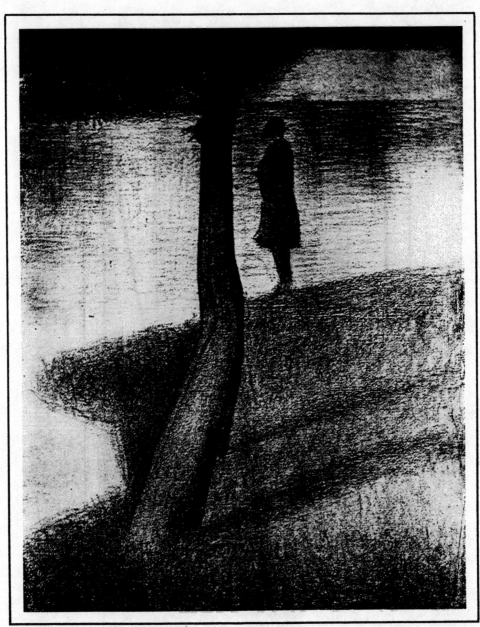

73. *Tree and Man,* Georges Seurat

142

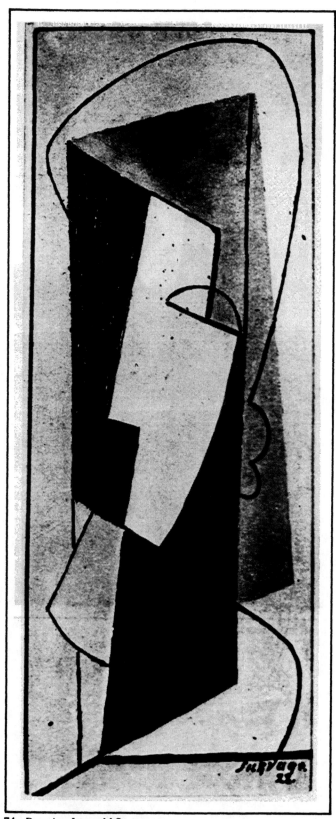

74. *Drawing,* Leopold Survage

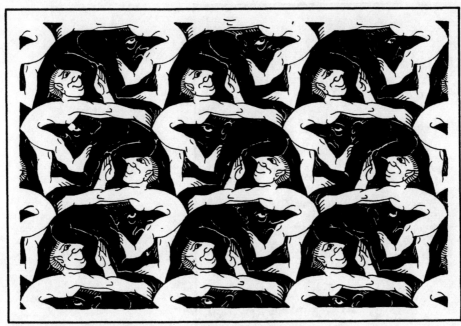

75. *Encounter,* M.C. Escher

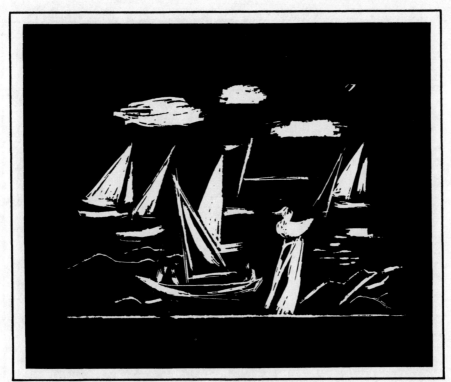

76. *Seascape,* Morris Davidson

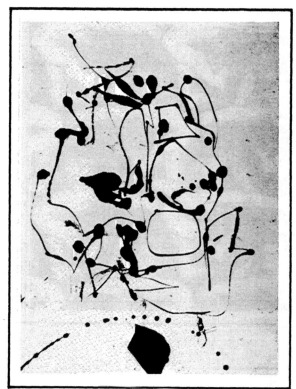

77. *Asheville,* Willem de Kooning

78. *Four Figures in Space,* Oskar Schlemmer

Chapter VIII

Signs and Symbols: What Does the Drawing Mean?

If you see a picture of a flag do you think of it as just a picture of a flag? Doesn't the artist have a message besides the design of the stars and stripes? What about a picture of a fist? Is the artist saying something about hand shapes, or is he making a statement about force?

Symbols are signs. They represent something. Perhaps they represent a person, an idea, a sound, a nation; practically anything can be suggested by a symbol. For example, a flag can represent its country; a bowler hat can represent Charlie Chaplin; a fancy knot can represent sailing courses. The letter "X" has a variety of uses as a symbol. It can be used to give the sound "ex." It can be the symbol of the unknown quantity, as in algebra. It can be the symbol of something forbidden, as the large "X" that you find over a cigarette in a *No Smoking* sign. The meaning of symbols changes with the time and place you live in: you'll find symbols used as long ago as ancient Egypt, and as recently as today's art.

Symbols appear often in pictures; sometimes they have a particular meaning, but sometimes they are just used as part of the design. In this chapter you'll try a few ways of including symbols in your drawings, both as representations of particular ideas, and as decorative parts of the composition.

Ancient Egyptians used a form of picture-writing called *hieroglyphics* to convey their message. This is the most basic kind of symbol. Each picture represents a specific thing that it looks like—the sun, the moon, the fish, the trees, etc. The artist drew a picture of what he wanted to describe. Though we think of it as a form of writing, it was also a collection of drawings. Many other cultures including American Indians, Mayans, and some Oriental peoples, have used a similar kind of writing-art.

In our time some children's books contain *rebuses*, which are stories told with a combination of pictures and words. They are often filled with puns, such as a picture of a bee, to suggest the word "be." But basically they picture a dog to represent a dog in the story, and a heart to represent love, for example. This use of pictures to tell a story is called *narrative* art. Since it is the easiest kind of symbol to use in drawing, you can start with an exercise in it.

145

EXERCISE 1 Narrative Symbols

What you will need: media of the teacher's choice.

Make up a very short story, perhaps six lines long. Design a *rebus* (some pictures, some words) on one large page. Use as many symbols as possible to get the story across. Use any symbols you like, but make them simple and clear. Your friends should be able to "read" your story-picture when you've finished it.

Sometimes symbols are used in art as part of religious rituals or story-telling. The earliest known drawing, made by prehistoric man on the walls of caves, were pictures of bison and other game. It is thought that the cavemen drew pictures of the animals as part of rituals involving successful hunting. In many ancient cultures pictures of gods, relics, and other religious symbols were the most basic (or only) subjects for their art.

As time went on, the use of symbols became more sophisticated. Rather than representing the very things they pictured, religious symbols became signs for an entire set of beliefs. The symbols of Christianity, such as the cross, appear throughout religious art. The cross represented the whole set of Christian beliefs. Each saint was suggested by a particular symbol drawn from the story of his or her life. If a viewer saw the symbol, he was expected to recognize the saint and remember the story.

Whole ethnic groups and nationalities can be symbolized in art. For example, our American eagle is a symbol. The Russian hammer and sickle suggests more than the two tools—it represents the idea of communism. France has a fleur-de-lis (a small white lily) in many pictures of its kings; it was the symbol of the French monarchy. By using these symbols, artists are saying more than they can possibly draw in one picture. Their audience knows what the symbols represent and they can "read" the meaning.

EXERCISE 2 Symbols Representing Religious
or National Ideals

What you will need: media of the teacher's choice.

Choose either a religious or nationalistic theme that has a well-known symbol or two connected to it. (If you can't think of one, choose a holiday such as Thanksgiving.) Construct a drawing that includes the symbols of your theme. Your picture can be either a storytelling picture (describing an event—such as immigrants seeing the Statue of Liberty) or just a design made of the symbols (Chanukah or Christmas symbols, for example). Your symbols should be big enough and important

enough to be central to your composition. Your friends should be able to guess your theme because of the symbols.

EXERCISE 3 Allegorical Pictures

What you will need: media of the teacher's choice.

Symbols can also represent other ideas. There are many pictures entitled "The Four Seasons," "The Five Senses," or "The Ages of Man," for example. These drawings are called *allegorical* because they don't tell their story by drawing full pictures of it, but by using symbols instead. For example, the five senses can be symbolized by a rose (sense of smell), a telescope or glasses (sight), a musical instrument (hearing), etc. This is a very popular technique and there are many famous works of art that are allegorical. Unlike the symbols in Exercise 1, the symbols in this work aren't narrative; they suggest something beyond what they picture.

Choose a subject with several different parts such as the three themes suggested above ("Five Senses," etc.); or invent your own theme. Some suggestions include "The Weather" (symbolized by umbrella, sunglasses, etc.) or "Childhood" (various toys, books, etc.). It will be easier to draw this exercise if you collect the items you are using as symbols and set them up as a still life to draw. Make a good arrangement so that each item is clearly visible. Title your picture when you are finished.

EXERCISE 4 Fantasy Pictures with Symbols

What you will need Try this picture in crayon, covering the surface of the paper with patches of color, then covering the entire picture in black crayon. Use a sharp tool to scratch out designs.

Sometimes the symbols in a picture have only a vague meaning, such as in a dream or fantasy scene. Particularly in our century artists have used recognizable symbols in weird and unexpected combinations. You've probably seen pictures that have eyes or hands or clocks or other symbols in them. Are they meant to suggest time passing? Or dreams? These works can be hard to understand, with their spooky combinations and out-of-place symbols. Often they aren't explained in

the title, or by the picture itself. But such fanciful pictures are fun to make and are a wonderful way for you to express fantastic images and ideas.

Follow the instructions for covering the paper with color, then black. Scratch out a variety of symbols from your own imagination. Make the symbols simple and recognizable, but not necessarily related in theme. Be imaginative!

In more contemporary art, symbols have a new use. They are simply elements of design. When the shape of a symbol is included just for the design, it may no longer be a symbol that represents an idea. And yet you may recognize it as a letter, a number, a clock, a wheel, or some other familiar shape. For instance, artists sometimes use letters for design. You've seen children's books that say *"A" is for Apple* and picture an apple. But if the "A" is not "for" anything, it is simply part of a composition. This is an example of one way modern art has moved away from traditional symbolism.

EXERCISE 5 The Symbol as Part of the Design

What you will need: media of the teacher's choice.

Choose either a letter or a number. Make it the center of your composition. Carefully divide your picture space into interesting designs around and including the number or letter you chose. The symbol can be hidden or disguised if you wish, or it can be clearly central, but be sure that it is part of the overall design.

If you use a whole collection of letter symbols, you'll find they can make an important part of your design, without reference to the meaning of the letters or words they may form. Artists such as Picasso and Braque often used strips of printed material, newspaper headlines, and music to add interest to their compositions. (When the artist sticks the newspaper or other material right onto the picture it becomes an art form called *collage.*) The use of different typefaces and headings from flyers or posters gives a work an unexpected quality, like "found" objects in a sculpture. Sometimes the theme of the picture can be related to what the words say. Most often these bits of printed material are used upside down, or even appear in foreign scripts, so that their meaning is deliberately unclear and *only their design is important.*

EXERCISE 6 Collections of Words and Symbols (I)

(Can be done with or instead of Ex. 7.)

What you will need: Find a large newspaper headline, flyer, poster, or other printed material that has big letters on it. Set up a simple still life (unrelated to the subject of your printed material) and place a few objects and your strip of printed material in the still life. (It can hang in back or sit on the table.) Use media of your choice.

Do as accurate a still-life drawing as you can, including the design made by the words in print.

EXERCISE 7 Collections of Words and Symbols (II)

(Can be done with or instead of Ex. 6.)

What you will need: This drawing should be done outdoors (or through the window if the scene is visible). Include a large sign or billboard in an outdoor landscape.

As in the still life above, the printed material should be part of the overall composition of your drawing. Design an interesting landscape including the billboard. Try to include the patterns made by the lettering and the patterns of grass, buildings, windows, etc.

If you compare these last drawings with your first narrative symbol drawing (the rebus) you'll see the great variety that is possible in using symbols in drawing. And at the end of this chapter you'll find some examples of how various artists used symbols.

OPTIONAL

Try a *collage*. This involves pasting together bits of paper that have different color, texture, designs (wallpaper, wrapping paper, etc.), or printing. This is good practice for composition and it is lots of fun. Use rubber cement for gluing. Try to vary the sizes and colors of each area.

FOR DISCUSSION

The following pictures by master artists use symbols in different ways. See if you can identify the aims of the artist, the themes of the pictures (with and without knowing the titles), and the ideas the artists tried to convey to you.

Master Drawings

79. Egyptian hieroglyphic

 How many recognizable symbols can you find? (You might look up in an Egyptian art and history book to discover what some of the symbols represented.)

80. Initial letter from the *Book of Kells* (Irish, 8th century)

 In what way is this letter-design quite modern?

81. *Letters A and E* from *Rebus Charvariques*

 How did this artist use the letters of the alphabet? Do they represent their sound? Are they merely for design purposes?

82. *The Triumph of Faith and Concord* (11th century manuscript)

 If the two figures at the top symbolize faith and concord (harmony), what do you think the rest of the picture represents? Would you understand this picture without its title?

83. *Juno Holding the Eye in His Hand* (Italian, late Medieval)

 The eye traditionally symbolizes jealousy. The peacocks drawing the carriage symbolize pride. Look up the story of Juno and relate it to the symbols in this drawing.

84. *La Cuisine* by Guiseppe Arcimboldo

 Why does the artist call his picture *Cooking*? What use does he make of the kitchen symbols?

85. *Veronica's Veil Imprinted with the Face of Christ* by Giovanni Guercino

 Look up the story told in this picture (you can find it in the encyclopedia, or the Gospels of Nicodemus). What is the function of the symbols in this drawing?

86. *Composition R U V* by Fernand Léger

87. *Still Life* by Juan Gris

What use is made of letters of the alphabet in these two drawings? Do they mean something?

88. *Lakeside* by Joan Miró

What signs or symbols does the artist use to show that this is a picture of a lakeside? Why does his drawing look like a child might have made it? What does the drawing's simplicity make you notice instead of details?

89. *Free in Strong Small Division* by Paul Klee

Why do you think the artist uses notes of music in the sun?

90. Cover of *Dada* magazine by Hans Arp

How does the use of different sizes and types of letters add to the design? How important is the newspaper? What are the major contrasts in the picture?

79. Egyptian hieroglyphic

80. Initial letter from the *Book of Kells,* Irish, 8th century

81. *Letters A and E, Rebus Charvariques,* circa 1840

82. *The Triumph of Faith and Concord,* Liége, 11th century

83. *Regina: Juno Holding the Eye in His Hand,*
Italian, late medieval

84. *La Cuisine,* Giuseppe Arcimboldo

85. *Veronica's Veil Imprinted with the Face of Christ,* Giovanni Guercino

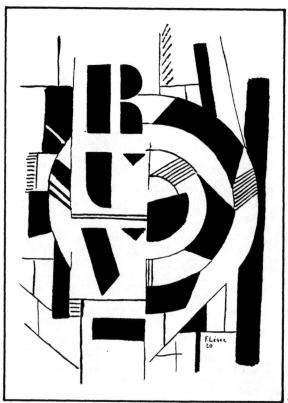

86. *Composition R U V,* Fernand Léger

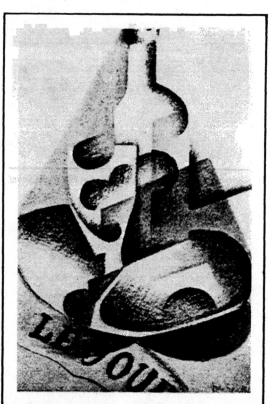

87. *Still Life,* Juan Gris

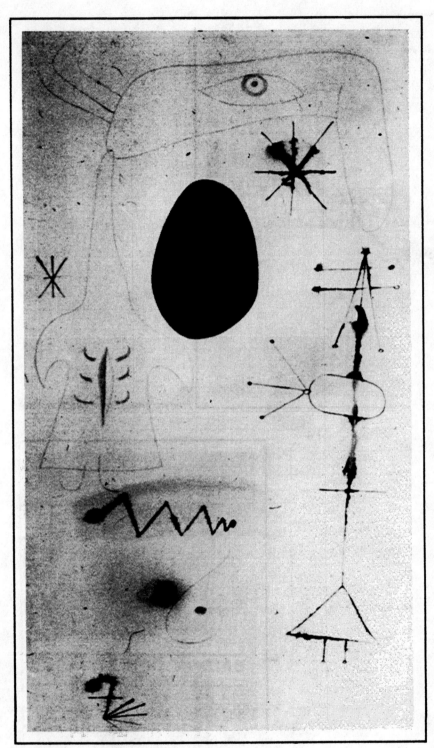

88. *Lakeside*, Joan Miró

158

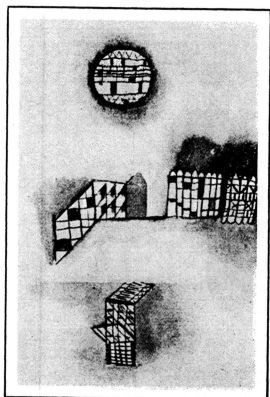

89.
Free in Strong Small Division, Paul Klee

90. Cover of *Dada* magazine, Hans Arp

Chapter IX

Bringing You a Message: Drawings That Tell a Story

Every drawing carries a message. Perhaps it's just a simple one, such as "this is what the tree outside my window looks like." But some drawings have much more complicated messages, from political viewpoints to emotional statements. In the next exercises you'll be experimenting with drawings that *tell* the viewer something, whether a story, an opinion, or a lesson.

The drawing that tells a story is familiar to anyone who has ever enjoyed book illustrations. A drawing that tells a story is usually filled with information: it describes a particular time or place or event with enough detail so that the viewer literally "gets the picture." Such drawings should be objective; the realistic details carry the message of the particular time and place for a viewer who wasn't there to experience it himself. It seldom exaggerates reality.

EXERCISE 1: Drawings That Tell a Story

What you will need: All drawings in this chapter can be done in media of the student's choice.

This picture can represent an event from a book, a newspaper, or your own experience. Choose a subject you're interested in; for example, don't make a war scene unless you want to draw the realistic details of battle. Choose an incident that can be summed up in one picture, not in a series of pictures, as in a comic strip. And you should pick a subject that is clearly *visual*. (For example, a feeling is not necessarily a *visual* subject, while a picnic at which you felt sad or happy *is*.)

Don't use symbols to tell your story this time. While a picture of a tank will symbolize war, it won't tell a full story unless it's part of a more detailed scene. Your picture should not need a title to explain itself, but it may help you to organize it if you begin with a simple written sentence describing

what you plan to draw. An example might be: "Mary arrives at the house and finds it boarded up and vacant"; or "The team had won and everyone was celebrating except the boy who had been benched for fighting"; or "The children were hungry and the house was filled with litter, but there was no food." Remember not to neglect the basic design and composition of your drawing; the details are put in *last*.

EXERCISE 2 A Drawing Expressing Your Feelings

While the drawings telling a story are based on objective details, some drawings carry a more personal message. Art can express feelings of loneliness, fear, happiness, etc. These drawings also tell a story, but from the *subjective* point of view. In order to draw this kind of picture you won't need so many details, but you *will* need a dramatic way to present your feelings.

You can experiment with dramatic media, with unusual composition, with different kinds of line, and with a subject that represents your feelings. For example, a drawing of a terrifying storm at sea would best be done in strong blacks with large, frightening forms, while a scene expressing loneliness might use a composition of vast areas surrounding a small and insignificant figure. A combination of the right media and a well-thought out composition should help put your message across.

Make a scene that pictures a particular emotion by using storytelling and a dramatic composition. You can use a subject from a book, from history, from your own experience, or from your imagination. Try to make your attitude and feelings so clear in your picture that your friends can tell what your theme is. You might want to try this drawing several times, with each example representing a different feeling or emotion. (Some theme suggestions: fear of a crowd; the loneliness of a child in a forest; the joy of walking in autumn; examples of anger, jealousy, etc.)

EXERCISE 3 Drawings That Teach

Another kind of picture which brings a message is the drawing that teaches. Instructional drawing is so common that

you're probably not even aware how much of it you see, whether in diagrams in your textbooks, in first-aid posters, or in directions for putting together a new gadget. A drawing that teaches carries a message just as illustration does, but its primary aim is to be clear and simple. You have to simplify all of the details and draw only the most basic elements. It avoids the details of Exercise 1 and the emotional quality of Exercise 2. (It should be noted that there are few people who can draw such practical teaching pictures; many of those drawings are very hard to follow!)

A drawing that explains how to do something or how an item is made can be a good drawing, as well as a useful one. Whether you're illustrating the proper way to do an exercise or how a plant looks under a microscope, your drawing should be clearly drawn and good to look at. Choose your subject carefully. Be sure you know exactly what part of the operation you plan to draw. For example, if you're going to make a drawing of how to tie a shoe, you'll find there are too many steps to draw all at once—you'd have to make several consecutive drawings. Such subjects as "Button up your coat when it's cold," or "This is the proper position for stretching before a run," or "The joints of the chair can be held together by two screws at each corner," can be drawn in single pictures. Your message should be clear, direct, and practical.

EXERCISE 4 Political Drawings

Another type of message drawing is one of the most common: political art. For centuries art of all kinds has been used to bring messages about social and political themes to the public. You've seen antiwar drawings, antidiscrimination drawings, and crusades for a great variety of social problems. (The power of "protest" art is so great that many governments have suppressed it. They recognize how important art can be in organizing public opinion.)

Political art should need no words to explain its message. (It's important to distinguish between drawings that are art with a political message, and posters and cartoons. A poster is a sign, and its main job is to carry a message; it is seldom made just as "art.") In the next exercise your drawing should have composition, good line, and all of the other characteristics of a good drawing, as well as a political message.

Choose a theme that interests you. Any social, moral, or political issue such as saving the whales, feeding the hungry, banning nuclear war, ending discrimination, or any local or school issue will do. The only requirement is that your viewpoint be clear. Don't make a drawing showing both sides of an issue. You must have an opinion to express.

There are a number of ways to go about making this drawing. One way is to give a detailed picture of a situation (as in Exercise 1) in which your attitude is made clear by lots of small and relevant details. Another way is to exaggerate the size of something you consider menacing in relation to its victims. Exaggeration stresses a point of view. A third way is to simplify your message so much that only the issue is strongly defined, with the rest of the drawing hazy or insignificant. A fourth method is to use a symbol of your subject, such as an empty bowl to suggest hunger, or a fence to suggest captivity. Try to make a strong and forceful drawing about something that matters to you.

EXERCISE 5 *Making a Cartoon with a Viewpoint*

What is the difference between a political-message drawing and a cartoon? Political cartoons are usually not fully detailed drawings. They exaggerate reality to make their points as strongly as possible. By accenting certain features of the characters cartoonists get their messages across. For example, if a public figure has a big nose, they might make his whole face into a nose. By exaggeration of characteristics they can make the person represent evil, stupidity, weakness, vanity, or whatever viewpoint they have of him or her. Cartoon drawings of people don't so much look *like* the public figure as they *represent* him or his views. Cartoonists also can use a line or two of writing, within the picture, or as a caption, or both.

Choose a news item from the newspaper or from a history book. Pick a character who is well-known or easily identified as a symbol (Uncle Sam, the Statue of Liberty, etc.). Make sure your own viewpoint is clear before you start. Begin by designing your cartoon so that the point you want to make is central to the composition. Exaggerate the parts of the drawing that make your view of the issue stronger. Emphasize the characteristics that are most important, while using the smallest possible amount of detail. A cluttered cartoon that requires a

character to speak in a balloon in the picture is usually too "busy" to make a strong statement. Use one line of caption instead.

If you're choosing a famous person, study his or her face in the photograph you use for reference. What are the most noticeable features? Note hair style, posture, clothing. The most familiar "trademarks" of public figures are the ones you will focus on, so that he is recognizable even without the caption or a name on his back. If you use a symbolic figure, you'll need only a few lines to indicate who it is (a tall hat and a flag for Uncle Sam, for example) so you can keep your drawing very simple. When you've finished, compare your drawing with your political drawing in Exercise 4. What are the differences?

OPTIONAL

For those who enjoyed doing illustrations, a good project is illustrating your favorite novel. Choose a particular event from each chapter and make a series of drawings.

For those who liked making cartoons or political drawings, a campaign for a school issue will give you a theme for a series of posters, or material for your school newspaper.

For those who liked the factual instructional drawing, turn this skill into a useful one by doing scientific drawings for special projects, or writing up technical subjects, such as the operation of a computer.

FOR DISCUSSION

Look at the drawings that follow. What kind of message art is each one? What message do they carry? Which are cartoons, which are art that expresses a viewpoint?

Master Drawings

91. *The Heir Disinherited* by Samuel Collings

What do you know about the contents of the will? In this storytelling picture, what are some of the details that show what's happening? Does the artist give an opinion?

92. *Poverty* (16th century Turkish)

How does this artist show poverty? Does the artist show how he feels about it?

93. *The Chamber of Genius* by Thomas Rowlandson

In this picture of the "genius" artist at work, what details show the attitude of the man who made it? Is he humorous or angry? Why do you think Rowlandson is known as one of the greatest artists of social satire?

94. *Comparisons Between Human and Animal Heads* by Thomas Rowlandson

What are the subtle ways the artist exaggerates features? In addition to the faces what else does the artist focus on for his satirical drawing?

95. *La Goulue and Valentin* by Henri Toulouse-Lautrec

How does this artist "capture" the personalities and style of his two subjects?

96. *For Discovering the Motions of the Earth* by Francisco Goya

97. *This Has Killed That* by Honoré Daumier

98. *Eviction* by George Grosz

In these three drawings, each artist has a strong viewpoint. What do you think each was trying to say? How do their different styles add force to their drawings? For clues: Goya's was referring to torture for making scientific discoveries; Daumier's referred to "packing" of the ballot box, and Grosz' to poverty.

99. *Scale* (19th century American)

100. *Bread in Bag* by Roy Lichtenstein

 Is there emotion or editorial comment in these two drawings? What messages do they convey?

101. *The Scream* by Edvard Munch

 How does this work show the artist's feelings? Does he accomplish this only by the expression of the face, or do the line and composition add to the emotional content? How?

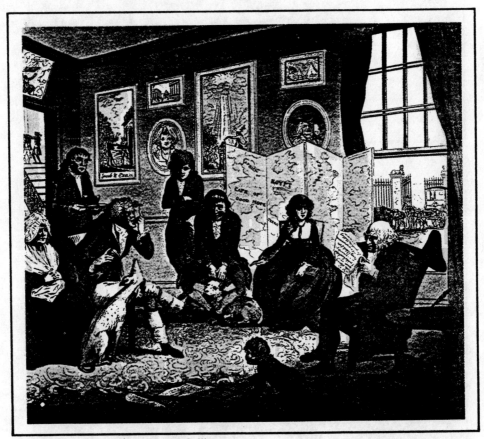

91. *The Heir Disinherited,* Samuel Collings

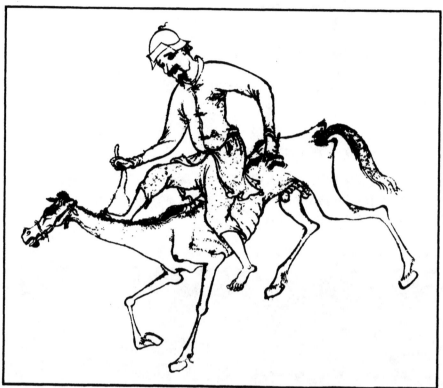

92. *Poverty,* Turkish, 16th century

93. *The Chamber of Genius,* Thomas Rowlandson

94. *Comparisons Between Human and Animal Heads,* Thomas Rowlandson

95. *La Goulue and Valentin,*
Henri Toulouse-Lautrec

168

96. *For Discovering the Motions of the Earth*, Francisco Goya

97. *This Has Killed That,* Honoré Daumier

98. *Eviction,* George Grosz

99. *Scale*, American

100. *Bread in Bag*, Roy Lichtenstein

101. *The Scream,* Edvard Munch

Chapter X

What You See—
And What You Imagine

In most of the exercises you've done in this course you've tried to draw what you see. But there is also another world to draw—the world of your imagination. Everybody's fantasy world differs. To some of you your imagination might picture outer space, with UFOs hurtling into blackness. Others might think of nightmare scenes, filled with odd-shaped beings or worlds of monsters and dragons. Fantasy is a great subject for art of all kinds, and the following exercises will give you a chance to try making up a world of your own in a drawing. Remember that no matter what the theme of your drawing is, you should try to make a good and unified composition, with a sense of space, interesting media, careful distribution of lights and darks, and a variety of line.

EXERCISE 1 Fantasy Picture Using Symbols

What you will need: media of your choice.

You've already made some pictures with symbols in them. Fantasy pictures are often filled with symbols that are odd or unrelated or make the picture seem unreal and frightening. The symbol of the eye, for example, appears in many pictures. In some early Christian pictures eyes represented a blind saint. In more recent works, eyes have suggested watching, or being watched. Sometimes eyes appear in a picture to symbolize the all-seeing. And in some modern works they can just be a symbol that the artist liked and thought "fit" well into his picture.

In this exercise you should choose a symbol (eyes, hands, a ring, a candle, etc.) and design a fantasy picture around it. Use your imagination! You can think of the symbol as the centerpiece of your drawing, using it just once, or you can use it repeatedly in a pattern. Use lines and textures that will make your picture fantastic (a night forest, for example, might be best done in the hazy quality of pastel chalks or charcoal).

173

EXERCISE 2 The Mechanized World

What you will need: Fine line of pen or pencil would be best for this detailed drawing.

Another kind of fantasy picture is based on the shapes and ideas of technology. The subject might be the screws, screens, computer chips, and other machinery of a totally mechanized world. You might also use the shapes and forms of rockets, astronauts, robots, and other space machinery. Sometimes geometric designs can suggest machinery with their interlocking sections and gearlike patterns.

For this exercise, make a drawing that suggests a technological fantasy. Use as much detail as you like, combining realistic drawing with patterns suggested by the shapes of technology. Be sure to use the full area of your paper, so that you don't end up drawing just one machine in an empty space. This is to be a picture of a whole scene of mechanical fantasy.

EXERCISE 3 Imaginary People

What you will need: media of your choice.

Making pictures of weird or imaginary people has been a favorite subject for centuries. There are many examples of pictures of strange beings imagined by artists; some have added wings, horns, or tails so that the body is half person, half animal. Others have "mechanized" the body, making it half person, half machine. Sometimes artists have made the body deformed, or almost unrecognizable as human at all. Use your imagination!

Begin with a lightly drawn sketch of a person or two, and then change as you wish. Make it as fanciful or odd as you can. Keep in mind that exaggeration of one part of the body (such as the hands) is one technique for you to try. Another is the "animalizing" of the body or some parts of it. You can also choose a theme (such as flowers, pots and pans, vegetables, etc.) and make the body entirely of those shapes and forms. These are just suggestions, though; this drawing is designed to stretch your imagination.

EXERCISE 4 *Dreams and Surrealism*

What you will need: media of your choice.

Dreams are another favorite subject for artists of all kinds. The unlikely combination of strange times, places, events, and unrelated people in one picture is always fascinating because it lets the artist carry the subject matter beyond reality. (The picturing of dreams in a realistic style is called *surrealism*.)

The curious thing about surrealistic art is that the subject matter is fanciful and strange, while the technique and style are realistic. What makes it fanciful is the mixing of impossible and unbelievable scenes with this realistic and believable drawing. (For example, one famous work by a *surrealist* shows a very realistic picture of a woman being stitched by a sewing machine!)

Choose two or three unlikely and unrelated ideas. (Some subjects by surrealistic artists have included a picture of a train that turns into a fish, a dinner table still life from which a snake appears, and a vase of flowers in which one flower has eyes.) Design your picture carefully, so that it will be accurately drawn with clear detail. Make the unrealistic part of it the *idea*, not the way you draw it.

EXERCISE 5 *Using Technique in Fantasy Drawings*

What you will need: charcoal or pastel on newsprint.

Sometimes the fantasy of a drawing depends on the media, rather than the strange or dreamlike idea of its theme. If you use a hazy and unclear media, you can suggest distant worlds and misty atmospheres like a dream you only vaguely remember. The technique you use can suggest mystery. What the surrealistic artist tries to accomplish with the use of precisely drawn but strange, unbelievable subjects, the more abstract artist might do with technique. Just as theatrical producers use rising steam or smoke on stage to suggest mystery, the artist can use hazy layers of chalk or charcoal to obscure the details in a drawing.

Choose a subject that you'd like to show in a delicate, hazy, or poetic way. (For example, night scenes, seascapes,

illustrations from horror or mystery books, etc.) Using your media freely, make an imaginary picture in which your technique is central to the look of fantasy. You can use symbols or other recognizable objects to add realism if you like. Your subject can be a dream, or a daydream, or any other fanciful scene. Use the full area of your paper. These exercises are only a few of the many kinds of fantasy pictures you can try. Experiment with these themes in other media, and with a variety of subjects.

OPTIONAL

Research or individual projects on surrealism can focus on the works of Dali, Masson, Ernst, and the Dada movement in art. Those interested in the scientific sides of fantasy drawing should look at the work of M.C. Escher, who combined elaborate perspective studies with fanciful images.

FOR DISCUSSION

Look at the following drawings and try to distinguish which ones are surrealist in that they use realistic techniques to present unbelievable images. Which are influenced by modern technology? Which use symbols? What do the symbols represent?

Master Drawings

102. *Fantastic Landscape* by Hieronymus Bosch

103. *Landscape* by Paul Klee

What do these two imaginary worlds look like to you? Are there any realistic features? What is the effect of combining the realistic with the less believable?

104. *Eyes in the Forest* by Odilon Redon

What do you think the eyes symbolize? How does the use of media add to the feeling of fantasy?

105. *Depth* by M.C. Escher

 What does the feeling of depth and space add to this mysterious drawing?

106. *Study of Machine* by Jean Tinguely

 Why is this such a futuristic-looking drawing? What symbols and shapes does the artist use to suggest the machine age? Do you think the mechanical look destroys the feeling of fantasy or adds to it?

107. *Dream of Ipthima* (illustration from *The Odyssey*) by John Flaxman

 How does the artist illustrate a dream? Does he use unrealistic images? Is this a fanciful drawing in technique, or in subject? Does it *feel* like a dream picture?

108. *Winter* by Giuseppe Arcimboldo

109. *The Mannequin* by Giorgio de Chirico

110. *Drawing* by Yves Tanguy

111. *Drawing* by Aubrey Beardsley

 In these four drawings of imaginary people, what are the symbols or ideas each artist used? What kind of comment about humanity might each artist have been making? How do exaggeration, technology, nature symbols, and other kinds of symbols add to the fantasy in each drawing?

102. *Fantastic Landscape*, Hieronymus Bosch

103. *Landscape,* Paul Klee

104. *Eyes in the Forest,* Odilon Redon

180

105. *Depth,* M.C. Escher

106. *Study of Machine,* Jean Tinguely

107. *Dream of Ipthima,* from *The Odyssey,* John Flaxman

108. *Winter,* Giuseppe Arcimboldo

109. *The Mannequin,* Giorgio de Chirico

110. *Drawing,* Yves Tanguy

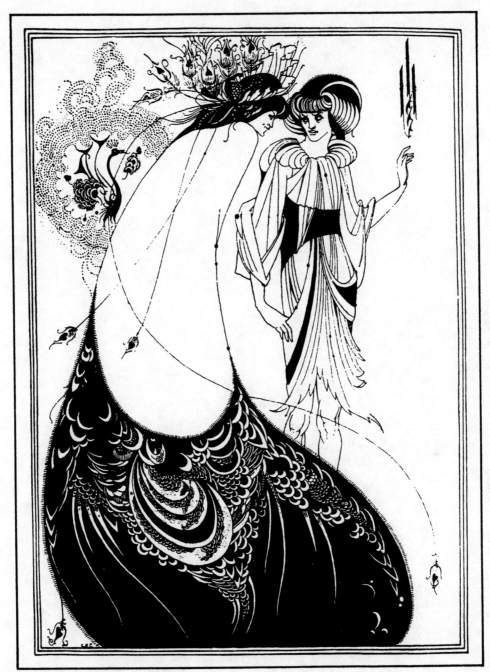

111. *Drawing*, Aubrey Beardsley

MASTER DRAWING LIST

Chapter I

1. Edgar Degas (French, 1834-1917) *Jockey on a Galloping Horse*
2. Georges Seurat (French, 1859-1891) *Man Playing a Drum*
3. Vittore Carpaccio (Italian, 1472-1525/6) *Fortified Harbor with Shipping*
4. Reginald Marsh (American, 1898-1954) *Locomotive*
5. Vincent van Gogh (Dutch, 1853-1890) *San Remy Under a Starry Sky*
6. André Masson (French, 1896-) *Drawing*
7. Chin Nung (Chinese, 1687-1764) *A Disciple of Buddha*
8. Nicolas Poussin (French, 1594-1665) *Two Horses*
9. Jean-Baptiste Greuze (French, 1725-1805) *Head of a Girl*
10. Edgar Degas (French, 1834-1917) *Drawing of a Dancer*
11. Max Ernst (German, 1891-1976) *The Year 1939*
12. Polidoro da Caravaggio (Italian, 1492-1543) *Landscape with Hermits*
13. Marino Marini (Italian, 1901-1980) *Horse and Cavaliers*

Chapter II

14. American (19th century) *New Bedford, Mass.*
15. François Boucher (French, 1703-1770) *A Corner of a Courtyard*
16. Canaletto (Italian, 1697-1768) *Houses near San Marta*
17. Morris Davidson (American, 1898-1979) *Village Street*
18. Pablo Picasso (Spanish, 1881-1973) *Houses*
19. Willem Buytewech (Dutch, 1591-1624) *Needlework by the Hearth*
20. Charles Sheeler (American, 1883-1965) *Interior with Stove*
21. K. Hokusai (Japanese, 1760-1849) *Chinese Farmhouse Among the Trees*
22. Paul Klee (Swiss, 1879-1940) *Schwabing, a Section of Munich*

Chapter III

23. Charles-François Daubigny (French, 1817-1878) *Drawing*
24. André Masson (French, 1896-) *Montagne St. Victoire*
25. Vincent van Gogh (Dutch, 1853-1890) *The Washerwomen*
26. Edgar Degas (French, 1834-1917) *Landscape in the Départment of L'Orme*
27. Henri Matisse (French, 1869-1954) *Ships in the Harbor*
28. Wols (German, 1913-1951) *Untitled drawing*
29. Claude Lorrain (French, 1600-1682) *Tiber Landscape with Rocky Promontory*
30. Paul Klee (Swiss, 1879-1940) *Kult-Statte*

MASTER DRAWING LIST

Chapter IV

31. John Constable (English, 1776-1837) *Elms in Old Hall Park*
32. Indian (circa 1800) *Cardinal Climber*
33. Jean-Baptiste Corot (French, 1796-1875) *Landscape*
34. Georges Seurat (French, 1859-1891) *Trees Along the Seine*
35. English (Circa 1425-1450) *The Tree of Confession*
36. Piet Mondrian (Dutch, 1872-1944) *Apple Tree*
37. Tani Bucho (Japanese, 1763-1810) *Fishing in the Melting Mountain*
38. Jean Honoré Fragonard (French, 1732-1806) *Cypress Avenue at Villa D'Este*
39. Vincent van Gogh (Dutch, 1853-1890) *Cypresses*
40. Arthur Dove (American, 1880-1946) *Sunrise II*

Chapter V

41. Juan Gris (Spanish, 1887-1927) *Still Life*
42. Ogata Kenzan (Japanese, 1663-1743) *Baskets of Flowers and Weeds*
43. Morris Davidson (American, 1898-1979) *Still Life*
44. Marsden Hartley (American, 1877-1943) *Bowl of Fruit*
45. Pablo Picasso (Spanish, 1881-1973) *Open Window with Pedestal Table*
46. Henri Matisse (French, 1869-1954) *Still Life*
47. Janos Balogh (Hungarian, 1874-1919) *Kitchen Still Life*
48. Georges Braque (French, 1882-1963) *Still Life*

Chapter VI

49. Peter Paul Rubens (Flemish, 1577-1640) *Male Nude Kneeling*
50. Jean-Auguste Ingres (French, 1780-1867) *Madam d'Hussonville*
51. Venetian (Circa 1600) *Archer*
52. Hard Schoen (German 16th century) Drawing from *A Treatise on the Proportions of Humans*
53. Amedeo Modigliani (Italian, 1884-1920) *Caryatid*
54. Japanese (17th century) *Scribe*
55. Rembrandt van Rijn (Dutch, 1606-1669) *Sketch of a Girl Sleeping*
56. Dunoyer de Segonzac (French, 1884-1974) *Dominique de Braga*
57. Paul Gauguin (French, 1848-1903) *Woman Seeding*
58. Auguste Renoir (French, 1841-1919) *Odalisque*
59. Jean Émile Laboureur (French, 1887-) *Three Men*
60. Pieter Breughel (Elder) (Flemish, 1525/30-1569) *Painter and Connoisseur*

MASTER DRAWING LIST

61. Leonardo da Vinci (Italian, 1452-1519) *Angel's Head*
62. Walter Sickert (English, 1860-1942) *Study of George Moore*
63. Henri Gaudier-Brzeska (French, 1891-1915) *Head of Ezra Pound*
64. Pablo Picasso (Spanish, 1881-1973) *Black Head*

Chapter VII

65. Peter Paul Rubens (Flemish, 1577-1640) *A Lioness*
66. Antoine-Louis Barye (French, 1796-1875) *Lion on the Prowl*
67. Persian (16th century) *Hunting Scene*
68. Francesco Primaticcio (Italian, 1504-1570) *Seated Figure of Juno*
69. Odilon Redon (French, 1840-1916) *The Day*
70. Victor-Marie Hugo (French, 1802-1885) *A Castle Above a Lake*
71. Josef Albers (German/American, 1888-1976) *To Monte Alban*
72. Rembrandt van Rijn (Dutch, 1606-1669) *Christ Appearing as a Gardener to Mary Magdalen*
73. Georges Seurat (French, 1859-1891) *Tree and Man*
74. Leopold Survage (French, 1879-1968) *Drawing*
75. M.C. Escher (Dutch, 1898-1971) *Encounter*
76. Morris Davidson (American, 1898-1979) *Seascape*
77. Willem de Kooning (American, 1904-) *Asheville*
78. Oskar Schlemmer (German, 1888-1943) *Four Figures in Space*

Chapter VIII

79. Egyptian hieroglyphic
80. Irish (8th century) Initial Letter from the *Book of Kells*
81. *Rebus Charvariques* (French, circa 1840) *Letters A and E*
82. 11th century manuscript from Liége *The Triumph of Faith and Concord*
83. Italian (Late medieval) *Regina: Juno Holding the Eye in His Hand*
84. Giuseppe Arcimboldo (Italian, 1527/30-1593) *La Cuisine*
85. Giovanni Guercino (Italian, 1591-1666) *Veronica's Veil Imprinted with the Face of Christ*
86. Fernand Léger (French, 1881-1955) *Composition R U V*
87. Juan Gris (Spanish, 1887-1927) *Still Life*
88. Joan Miró (Spanish, 1893-1983) *Lakeside*
89. Paul Klee (Swiss, 1879-1940) *Free in Strong Small Division*
90. Hans Arp (Swiss, 1887-1966) Cover of *Dada* magazine

MASTER DRAWING LIST

Chapter IX

91. Samuel Collings (English, 18th century) *The Heir Disinherited*
92. Turkish (16th century) *Poverty*
93. Thomas Rowlandson (English, 1756-1827) *The Chamber of Genius*
94. Thomas Rowlandson (English, 1756-1827) *Comparisons Between Human and Animal Heads*
95. Henri Toulouse-Lautrec (French, 1864-1901) *La Goulue and Valentin*
96. Francisco Goya (Spanish, 1746-1828) *For Discovering the Motions of the Earth*
97. Honoré Daumier (French, 1808-1879) *This Has Killed That*
98. George Grosz (German, 1893-1959) *Eviction*
99. American (19th century) *Scale*
100. Roy Lichtenstein (American, 1923-) *Bread in Bag*
101. Edvard Munch (Norwegian, 1863-1946) *The Scream*

Chapter X

102. Hieronymus Bosch (Flemish, c. 1450-1516) *Fantastic Landscape*
103. Paul Klee (Swiss, 1879-1940) *Landscape*
104. Odilon Redon (French, 1840-1916) *Eyes in the Forest*
105. M.C. Escher (Dutch, 1898-1971) *Depth*
106. Jean Tinguely (Swiss, 1925-) *Study of Machine*
107. John Flaxman (English, 1775-1826) *Dream of Ipthima*, from *The Odyssey*
108. Giuseppe Arcimboldo (Italian, 1527/30-1593) *Winter*
109. Giorgio de Chirico (Italian, 1888-1978) *The Mannequin*
110. Yves Tanguy (French/American, 1900-1955) *Drawing*
111. Aubrey Beardsley (English, 1872-1898) *Drawing*

PICTURE SOURCES

Albertina Collection, Vienna: 9, 15, 29, 60, 102; Biblioteca Reale, Turin: 61; British Library: 32; British Museum: 3, 13, 34, 37, 55, 65, 66, 70; Brooklyn Museum of Art: 4, 12, 33, 39, 44; Buchholz Gallery: 24; Collection of the author: 17, 42, 76, 79; École des Beaux Arts, Paris: 84; Hirshhorn Collection, Washington: 6; Kleemann Gallery: 89; Kunsthalle, Hamburg: 5, 19; Kupferstickkabinett, Basel: 78, 86; Louvre: 23, 49, 68; Musée Condé, France: 8; Museum of Modern Art, Paris: 53; New York Public Library Picture Collection: 11, 14, 52, 81, 82, 83, 106, 108, 110, 111; Private Collections: 2, 20, 35, 36, 109; Rijksmuseum Kroller –Muller, Otterlo: 25, 41, 87; St. Louis Art Museum: 51, 67, 77, 88, 104, 107; Solomon R. Guggenheim Museum: 28; Stadtische Museum, Wuppertal: 73; Trinity College, Dublin: 80; Versailles Collection: 57; Victoria and Albert Museum, London: 21, 31.